THE ULTIMATE BOOK OF
DRAWING AND ILLUSTRATION

A COMPLETE STEP-BY-STEP GUIDE

THE ULTIMATE BOOK OF
DRAWING AND ILLUSTRATION

PETER GRAY

SIRIUS

SIRIUS

This edition published in 2023 by Sirius Publishing, a division of
Arcturus Publishing Limited,
26/27 Bickels Yard, 151–153 Bermondsey Street,
London SE1 3HA

ISBN: 978-1-3988-2619-9
AD011097UK

Printed in China

Contents

PART I: *Essential skills and techniques* 8

Looking and seeing 10

Materials 12

Mass, shape, form and detail 13

The basic drawing process 14

Multiple masses 16

The page 18

Measuring proportions 20

Measuring angles 23

The human figure 24

The human head 27

Feeling for form 30

Receding angles 32

Perspective theory 34

Perspective in practice 38

Shapes in perspective 40

Three-point perspective 42

Variations of line 44

Introducing texture 46

Light and shade 48

Shading and hatching 50

Charcoal 52

Aerial perspective 54

Transparent media 56

Sketching with wash 58

Brush drawing 60

Tonal brush drawing 62

Marker pens 64

Opaque media 66

PART II: *Seeking essential truths* 68

Framing and selection 70

Composition 72

Restricted tone 74

Continuous line 76

Blunt instruments 78

Working at different scales 80

Time limitations 82

Sketching 84

Simple form 88

Elegance 90

Symmetry 92

Geometry and structure 94

Bright light 96

Dramatic light 98

Rear lighting 102

Atmosphere 104

Spatial depth 106

Surface 108

Real life 112

A complex scene 114

Wear and tear 116

Personality 120

Narrative 122

Continued >>

PART III: *Interpretation*...............................124

Subject matter...............................126

Viewpoint...............................128

Looking down...............................130

Looking up...............................132

Viewpoints near and far...............................134

Breadth of view...............................136

Making arrangements...............................138

Drawing language...............................140

Pencil line...............................142

Ink line...............................144

Ink and texture...............................146

Tone...............................149

Toned paper...............................152

Tone and texture...............................154

Experimenting with texture...............................156

Illumination...............................158

Drawing with light...............................160

Drawing with an eraser...............................162

Composition...............................164

Distilled composition...............................166

Combined composition...............................168

Condensed composition...............................171

Collated composition...............................174

Creative composition...............................178

Framing...............................180

Emphasis...............................182

Framing...............................184

PART IV: *Invention*188

Illustrative processes190

Purity of design192

Decorative illustration194

Metamorphosis196

Beyond reality198

Anthropomorphism200

Making faces202

Stylistic portraiture204

Caricature by stretch206

Stylistic figures208

Invented figures210

Costume and character212

Character and expression214

Drama and narrative216

A sinister illustration218

Developing a scene221

Heroic character design224

Other fantasy characters226

Non-human character design228

Inspirational devices230

Blots and doodles ..232

Fantasy landscape ..234

Landscape design ...236

Making a statement238

Index ..240

PART I: *Essential skills and techniques*

Many people have doubts about their ability to draw, but the very fact that you're reading this book suggests that you possess the most essential quality for learning how to do it – the willingness to give it a go. It's surprising how many people say flatly that they cannot draw and are so convinced of this that they don't think it's worth attempting to develop some skill.

To say this book is suitable for beginners is only partially true, because in drawing there is in fact no such thing as a beginner. Every child feels the compulsion to draw and does so with a confidence we can only marvel at in adulthood. That confidence to set down marks on paper with boldness is one of the greatest assets an artist can attain, and this book aims to bring it out in readers of all abilities.

While all the traditional subject areas are covered – still life, landscape, architecture and interiors, human and animal form and portraiture – they don't feature as individual blocks of study. Instead, the course charted here is through the processes of drawing, starting from the most basic of techniques and taking on new subjects as stepping-stones towards developing a sophisticated style of working.

However, sophistication shouldn't be understood here as complicated and time-consuming. The main aim of this book is to instil in its readers that there's much more, and very much less, to drawing than reproducing photographic reality. The desire for realism is the greatest barrier to beginners taking up the practice and the reason why they often become disenchanted once they've started. Instead, we shall focus on simplicity. A work of simplicity is a work of sophistication. Any fool can make things complicated, but it takes effort to stick to clear intentions and to know when to stop fiddling.

After making your way through the first part of this book you will have acquired a grounding in all the basic essentials of drawing theory: proportion, perspective, light and shade, mark-making, and so on. You will have experience of a broad enough range of subjects and techniques to identify the areas of study that most appeal to you and will be on your way to establishing your own style of drawing. Then you will be ready to progress to part two and begin making positive artistic statements with confidence and simplicity.

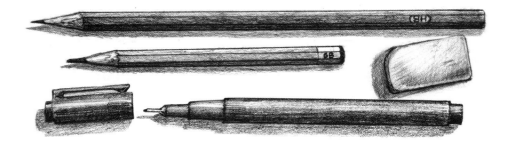

LOOKING AND SEEING

We look at objects all day long, but in our busy lives we do it merely to identify them. For example, you look into a kitchen cupboard, select a glass, fill it with water and casually drink from it. You probably never take the time to consider the woodgrain on the cupboard door, the industrial contours of the tap, the sparkling reflections on the glass, or the mysterious, distorted, upside-down world visible through the water.

A good drawing doesn't come out of mere glimpses of a subject, but of a period of time spent studying it, analyzing it and relearning what you know about it, accepting that things do not necessarily look the way you have always thought they do. By learning not merely to look but to really see, you will enter a new relationship with the world around you – one of immersion, engagement and, often, wonder.

► The first drawing is clearly a cushion shape: the outline pulls in correctly at the sides, it has a bit of shading to suggest its bulk a nd even some neat piping running around the edge.

► The next version is more typical of the cushions we come across in real life (at least in my house), squashed, wrinkled and set at an angle to the viewer. We rarely see objects in pristine condition from face-on viewpoints – and they are in any case less interesting to draw.

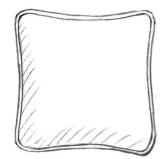

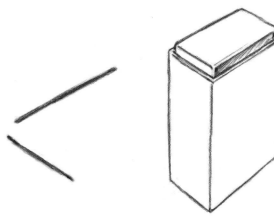

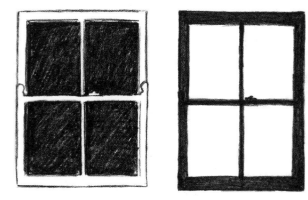

▲ It would be difficult to convince anyone that these lines are horizontal. They are clearly set at steep angles, but that is how you would have to draw them for a convincing impression of a matchbox standing on a level surface.

▲ Here are two drawings of a white window frame. At night its whiteness stands out clearly against the darkness outside, but during the day the brightness of the sky changes our view of it entirely, making it appear black. Given such a changeable visual world, we have to reappraise a subject with every new drawing and expect the unexpected.

▶ It doesn't take a seasoned artist to identify this as a young girl, but recognizing a subject and drawing it are two different things. Let's consider some of the many kinds of error of perception a novice artist might make when drawing a subject such as this. To most people, the main feature would be the face, in which we recognize all the character and expression of the individual. But have you noticed how small it is? By my calculations, it's less than 5 per cent of the drawing's surface area. In this profile view, the features of the face are at the very front edge of the head, and only occupy the lower half of that.

Now look at how very broad the head is, not the egg-shape you may have in your mind but, from a side view, quite round – much wider than most beginners would allow in their drawings. Note too how far back the ear sits.

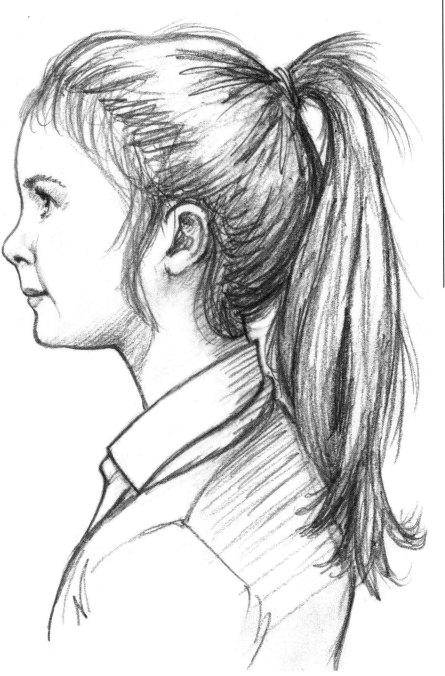

See also how the neck slopes forward – not upright, as many assume – and how long it is, within and above the collar. That collar, which we know to be round, here looks like little more than a flat rectangle. The hair, at first glance neatly tied back, is not actually so neat; the hairline is surrounded by wispy strands, which are really quite long by the ear, and odd tufts stick out of the hairband. Notice the bulge of the forehead, the heart-shaped lips, the triangular eye – and so the list goes on.

Seeing and judging things clearly and truthfully is a big first step towards being an artist. Now all you have to do is learn how to reproduce them on paper!

MATERIALS

It's very easy to be seduced by the array of materials available in an art shop, but bear in mind that Leonardo produced masterpieces of draughtsmanship with little more than a crayon. For most of the exercises in the book you will need only a very basic kit. In fact, cheap, basic materials are the best ones to use at this stage; expensive ones can make you hesitant and then your drawings will be stilted.

PENCIL

Most artists use soft pencils, which make lovely dense black marks. They are labelled in grades from B to 6B (very black). Hard pencils (H–6H) are of less use to the artist, but can be handy for making light guidelines. HB is the grade of a standard office pencil, neither very soft nor hard. Two or three pencils will suffice to start with: H or HB, B or 2B, and a 4B or 6B.

Sharpening

A pencil sharpener, especially one with a reservoir for the shavings, is a handy gadget to carry around with you on sketching trips. However, for best results, use a sharp blade or penknife to whittle your pencils to a point, exposing a good length of lead.

ERASER

An eraser is essential. In the course of a drawing you may wish to remove or soften mistakes, smudges and guidelines or you may change your mind about how the drawing should go and erase whole areas. You can also draw highlights with your eraser. All of this work is useful to your artistic development, since you learn from your mistakes.

PEN

The use of ink brings different qualities to a drawing and the act of making it. There are many types of ink, pen or brush available, but for early dabblings an artist's felt-tip drawing pen will suffice. Choose a 0.5mm nib for a good all-round size, or you could go for a couple, for example 0.3mm and 0.8mm.

PAPER

As you develop you may like to use better-quality papers, but to start with I recommend that you use any cheap white paper, perhaps in a sketchbook or as loose sheets with a drawing board to lean on. A3 is a good size (42 × 30cm/16½ × 12in), but A4 (30 × 21cm/12 × 8¼in) will suffice for most of the demonstrations in this book.

MASS, SHAPE, FORM AND DETAIL

Before you start to do any drawing, it's useful to acquire an understanding of some basic drawing terms and principles. The following examples represent some of the different aspects of a object you will need to consider in the process of drawing.

Mass

At the most basic level, objects you are going to draw can be thought of as just masses – shapeless blocks of certain sizes. It's worth spending a moment on the idea of masses because they are the foundations upon which most drawings are built.

Shape

Within the masses are shapes, which we can think of as the basic overall outlines of individual objects.

Form

The subtler refinement of shapes is known to artists as 'form', by which we may mean an object's sense of solidity, internal construction, and so on.

Detail

Yet another step of refinement concerns the detail – the surface markings, patterns and textures of an object.

THE BASIC DRAWING PROCESS

Most drawings follow the same basic process, essentially working from large to small – that is to say, starting with the mass or masses of a subject and working towards smaller details. Along the way, guidelines are generated to help break the subject down into manageable and logical chunks.

► Simple though it is, this rudimentary oval immediately establishes the general mass of the subject, its height relative to its width and its general shape. This stage took no more than a second or two to draw.

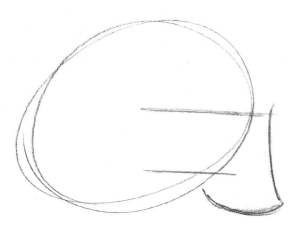

◄ Next, I quickly marked the secondary mass – the projecting face area and rough lines for the brow and cheekbone.

► Embarking on the network of guidelines, it was now quite easy to place the main shapes and features that make this drawing recognizable as a skull.

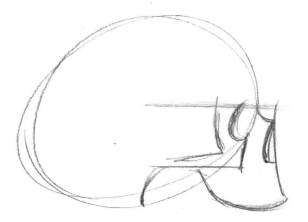

ARTIST'S ADVICE

Using a harder pencil or drawing lightly for underdrawings and guidelines makes the marks easier to erase. Here, I have drawn quite heavily with a soft pencil for the sake of clarity.

▶ Next I tweaked the original oval to follow the subtler outline of the real object, which is rather more angular than it may first appear.

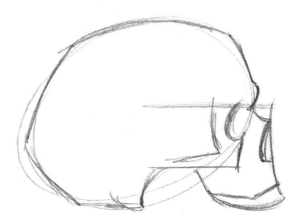

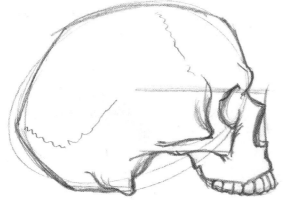

◀ With most of the detail in place it was now a case of refining and defining the outlines, using more pressure on the pencil or switching to a softer, blacker one.

▶ At the final stage, I carefully erased all the guidelines, dirty marks and mistakes. Adding a few strokes of shading helped to clarify the form of the skull.

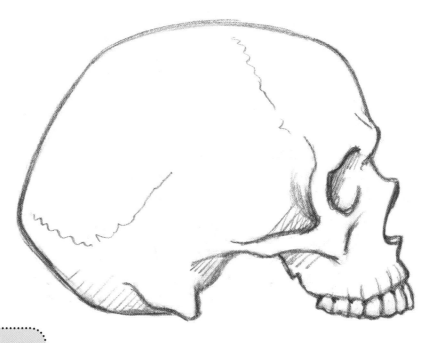

ARTIST'S ADVICE

To erase marks around small details, use the corner of an eraser, which can be reshaped with a knife when it wears blunt.

MULTIPLE MASSES

More commonly a subject will be composed of more than one basic mass. This example is made up of three distinct areas, but it need not present too much of a challenge if the masses are established clearly from the beginning.

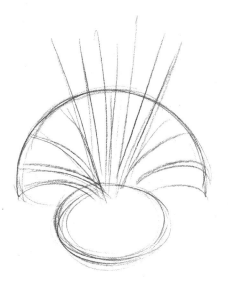

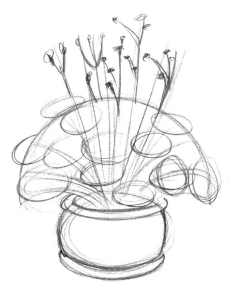

▲ Ignoring any detail, I simply marked the broad shapes to position them and their relative sizes on the paper. I have also indicated the general thrust of the plant's growth emerging from the pot, the ends of which mark the overall height of the upper mass.

▲ Next I looked at the smaller shapes within the masses, marking the rough sizes and positions of the larger leaves as well as the individual flower stems and their end points. I added a little shape, or form, to the pot. This very simple network of pencil guidelines is all that's needed to be able to add detail with confidence.

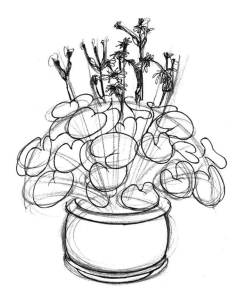

◄ In this case I decided to continue in ink, using a fine felt-tipped drawing pen, but you can equally well use pencil. First I drew the large foreground leaves, looking at them carefully to capture their individual shapes and sizes. Then I worked on the partially obscured leaves and added the main flower stems, again referring closely to the subject and veering away from the guidelines where necessary.

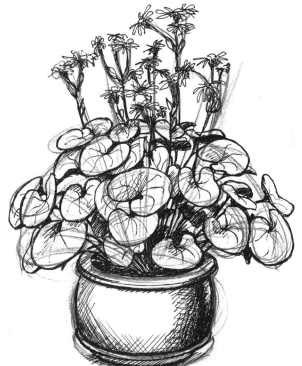

◄ With the main leaves in place, it was easy to draw the other leaves and stems in the spaces in between. After completing the flowers and the pot, I added some rough shading to give the drawing solidity and depth. (This is covered in more detail on p.50–51.)

▶ Here you can see why I used ink for the final drawing. As it is a stable medium that cannot be rubbed out or smudged once it is dry, all guidelines can be erased quickly in broad strokes of an eraser, leaving a clean drawing without the need for any fiddly erasing.

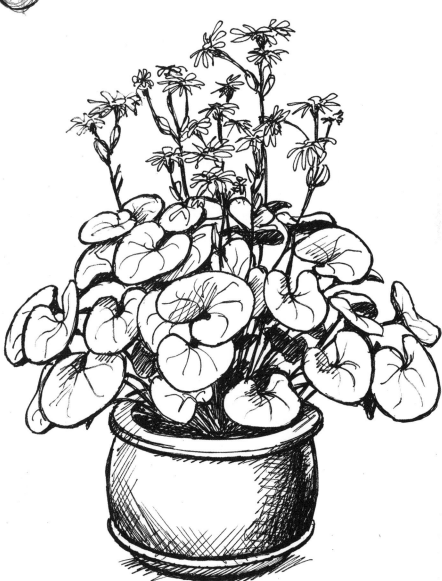

THE PAGE

Though the type and quality of paper is not very important for learning to draw, you must still consider how your sheet of paper can be employed for the best results.

FORMAT

Before drawing anything, turn your paper around to the appropriate format for the subject. Working with the paper laid out horizontally will produce a drawing in what is known as 'landscape format'; vertically, the drawing will be 'portrait format'.

18

SIZE

Try to work at a decent size that will allow you space to draw freely; if you start off too small the drawing will quickly become stilted and difficult to develop. Your under-drawings should fill a good portion of the paper.

However, if your intention is to make very quick studies, it may be wise to avoid making them too large and unwieldy. Working several to a page saves time and keeps your pencil flowing.

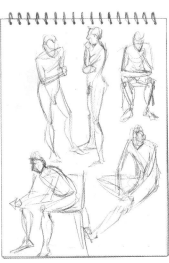

FILLING THE PAGE

I did this little sketch in an A6 sketchbook (14 × 10 cm/5¾ × 4 in). I made a conscious decision to let the plants fill the whole page, cropped off by the paper's edges. This makes for a sense of liveliness.

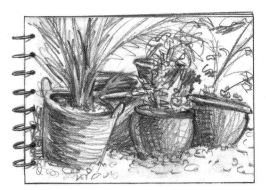

GOING OFF THE PAGE

During the process of drawing, some elements often end up without sufficient room on the page. Rather than squashing things up to make them fit the paper, it's far better to draw them to proportion and accept that they will run off the page.

SELECTED DETAIL

You may choose not to draw a subject in its entirety but to select the parts that interest you most.

SKETCHBOOKS

Working in sketchbooks is a good way to keep your drawings together and in order. A spiral-bound A4 book is a good-all round size but is rather large for general portability. Drawing away from home provides excellent practice, so I recommend that you also buy a smaller sketchbook to carry in your bag or pocket for whenever the opportunity arises for a quick sketch. Many of the pictures in this book are impromptu sketches in pocket sketchbooks.

MEASURING PROPORTIONS

This subject, a sculptural detail from a fountain, is rather more complex than those on the previous pages. Though it can easily be thought of as a series of masses and shapes, it may be best approached in a different way. The following demonstration involves a technique known as sight-sizing that's used by many artists. Note that the scale of your subjects and your drawings won't always comply with the convenient measurements of a pencil; it may be necessary to measure and mark off in fractions or multiples of pencil lengths.

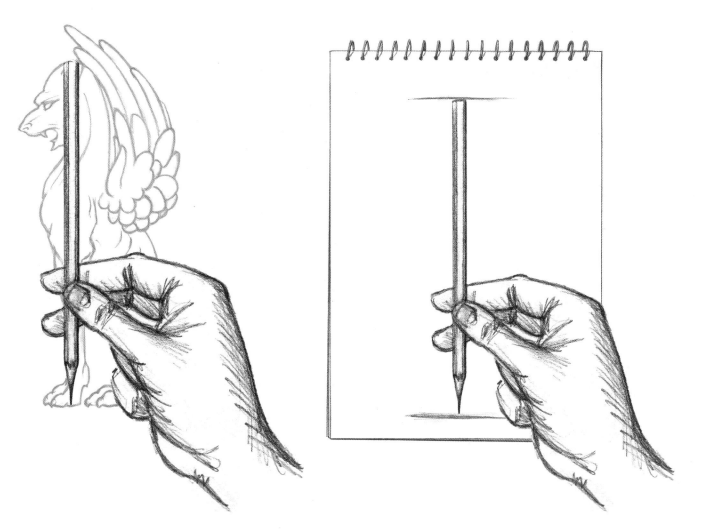

SIGHT-SIZING

Imagine you're standing at a distance from this statue and holding out your pencil with your arm fully extended and elbow locked straight. This gives you a stable measure of relative distances. Let's say that from your standing point, the statue appears to be the same height as your pencil. You can then mark on your paper the upper and lower extents of a drawing, with one pencil length in between, in this case making sure to leave space above for the wing tip.

◄ You can then refer back to the subject and, with your thumb tip against the pencil, assess the length of other proportions. This diagram shows measures and marks for the underside of the wing (which happens to be about halfway up) and the rough placement of a vertical line that runs through the foreleg and up into the chest and neck.

▲ With the overall height, width, and a couple of internal measurements, I made a kind of grid, into which an accurately proportioned drawing should fit quite easily

▲ Within the grid it was now easy to mark the curves that make up the main masses of the statue with some accuracy, using the sight-sizing method to check any more proportions I was unsure of.

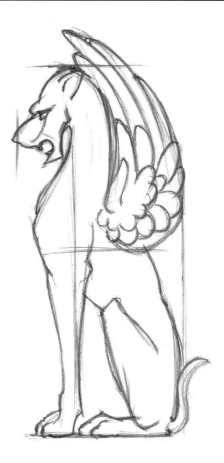

► It didn't take long to construct a more or less complete outline over the guidelines, since this consisted of little more than a joining up of the various parts of the guideline framework.

▲ With all the hard work done a more precise outline fell into place quite quickly, with the details worked up within the established shapes.

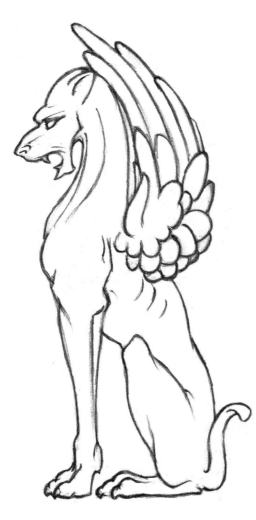

◄ With the guidelines erased and the fuzzy outlines cleaned up, the result is quite a bold and sturdy-looking figure.

MEASURING ANGLES

Equally important as the proportions of the shapes and lines of a drawing are its angles. Nearly all drawings will involve assessing and setting down angles in some way or another. Once again, the pencil comes to the rescue as a very quick and effective aid to judging and copying the angles that make up any subject.

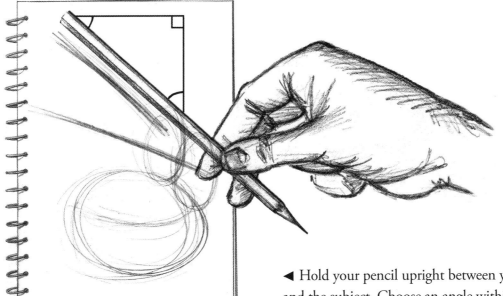

◀ Hold your pencil upright between your line of sight and the subject. Choose an angle within the subject and tilt your pencil clockwise or anti-clockwise until it matches. Then, without changing its angle of tilt, simply move the pencil down to your paper and mark it on your drawing. Once you have a few strong angles marked down, even quite complicated drawings will fall into place relatively easily.

THE HUMAN FIGURE

The human body, or figure, is one of the great traditional subjects of drawing, and one that provides fascinating challenges for even the most seasoned of draughtspeople. It can be a subject of great sophistication, but the techniques we have covered so far will be sufficient to make a good start. This demonstration will involve mass, shape, form, proportions and angles, and will also introduce the ideas of balance and thrust.

24

◄ Having a general idea of the proportions of the figure can be very useful, especially for standing poses. Most adult bodies, male or female, short or tall, are around seven to eight heads tall. This means that the head, whatever its size, will fit into the total height of the body seven or eight times, making convenient divisions around the levels of the chest, waist, hips and knees. This diagram also shows that the shoulders are generally two head lengths wide and a trim waist is around one head length wide.

◄ In any standing figure there will always be one or more tensions that govern the balance and actions of the body. These can be captured as straight or curved guidelines that provide useful aids to drawing. In the pose opposite and on p.26, the line of balance is quite clear to perceive, running up through the leg and the upright torso. It also has a thrust to the right, a line of action that runs at an angle through the left leg up towards the outstretched arm. The pencil can be used to assess the angle of this action line and mark it on the paper.

► Once I had marked the upper and lower extents of the figure, it was easy to divide and subdivide the height to provide rough pointers for drawing the whole body.

► Next I quickly roughed in the main masses and shapes that make up the body: the head, torso, hips and legs.

25

► Using the pencil's length again to assess the subtler angles of the extremities, I marked the shoulder line and the general thrust of each arm. Also important were the forward tilt of the neck, the angle of the face and the trailing foot.

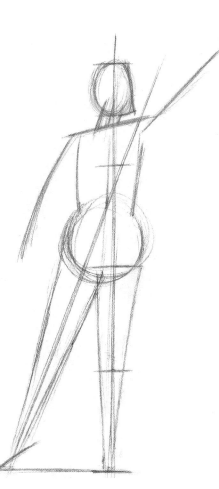

▶ Next, with close attention to the
model, I revised and developed the
outline, making changes to the overall
shapes if necessary. At this stage the
broad and angular marks started to
become sensuous curves. I took care to
measure any proportions I was unsure
of, such as the length of the arms.

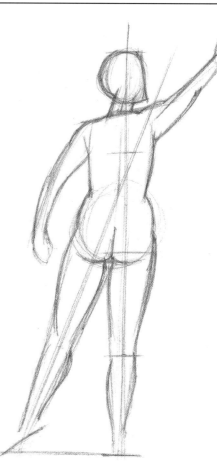

▼ From there on
it was just a case of
continuing to refine
the drawing, always
checking it closely
against the model.

▶ With all the basic
drawing in place, I
could erase all the
guidelines and firm
up the outlines to
leave a clean and
accurate line drawing.

THE HUMAN HEAD

The human head is another subject for which it may be useful to have a general idea of proportions. Although every head is different, they do follow a similar structure. The diagram below is not really to be thought of as the first stage of drawing but rather as a set of general proportions to keep in mind.

▶ Adult human heads, male or female, can be thought of as upside-down egg shapes. A vertical centre line helps to place the features with a degree of symmetry, and another line bisects the head horizontally at about the halfway point. This 'eye line' may be divided into five equal lengths as a rough guide to the width and placement of the eyes. Halfway down the bottom half, another guideline marks the bottom extent of the nose and ears.

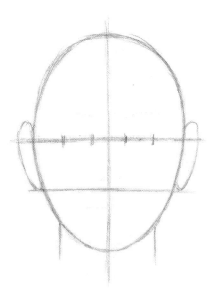

27

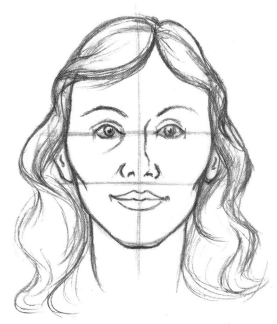

◀ Of course real faces are much more interesting than any diagrammatic generalization. Through careful observation of a subject and perhaps some sight-size measuring, you will see where your subjects subtly diverge from the standard.

▶ This face is male and much older, yet the features fit generally into the same template. However, on closer inspection we see that the head is narrower, the nose longer and so on. This face is also not very symmetrical, as the centre line helps to show. Such slight divergences from the template are very important in capturing likenesses.

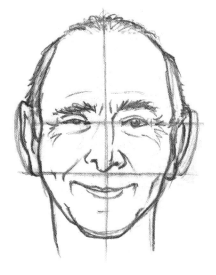

THREE-QUARTER VIEWS

Most of the subjects so far have been drawn from simple front or side views. Drawing from more complex angles of view demands that we think of the subjects in more of a three-dimensional way.

► This head is turned so that we can see both the front and side, which is to say a three-quarter view. As before, I began with the mass – here a rough oval. For this angle of view it's helpful to mark the vertical centre line to help in placing the features on either side of the face. Note that the line follows the curve of the head. The eye line remains straight.

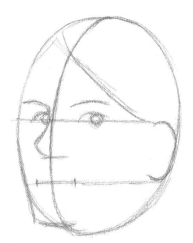

◄ Next I roughly placed the main features. Faces are full of interesting contours, so when you draw them think of the centre line as a very rough guide and be led by observation of the subject. For example, this woman's eyes are quite deepset, so they sit some way back from the front of the face.

► With the detail worked up it's clear that the lower face sits in front of the centre line and the face is somewhat slimmer than the original oval guideline. The face should look symmetrically balanced at this stage – if it doesn't, erase any dubious parts and redraw them.

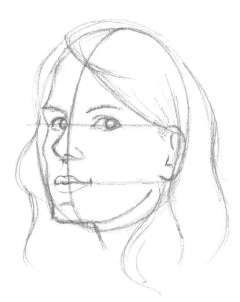

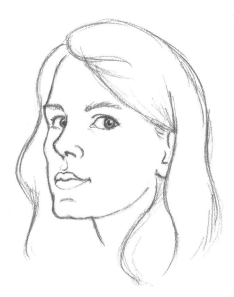

◄ Finally, I erased the guidelines and refined the features, keeping everything simple and clean by using as few lines as possible. The hair is drawn as a general shape with just a few indications of texture.

A HIGHER VIEWPOINT

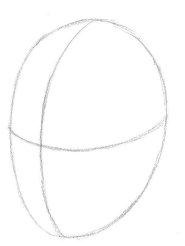

◄ With high or low viewpoints lateral guidelines become more important in order to help place features at the appropriate height. Looking down on this head, I've drawn the mass and vertical centre line and also a curving eye line that wraps around the mass below the halfway level.

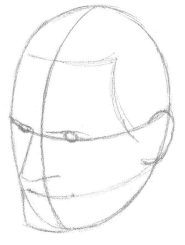

► I drew the head following the same principles as before, but with extra attention to the levels of the features. It's easy to assume that you have a good sense of a familiar subject but careful observation may throw up some surprises. From this angle of view, for example, some elements almost overlap, such as the brows covering the tops of the eyes. Extending the line of the mouth will help in finding the level of the ear.

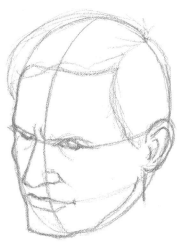

◄ Once the features are refined and the outlines of the face are set down, the drawing develops into a believable solid form.

► With the guidelines erased, a few wrinkles and contour lines can be added to lend the head character. The main thing to aim for is convincing heads that work three-dimensionally. Don't worry if you don't achieve perfect likenesses at this stage; they will come with time and practice.

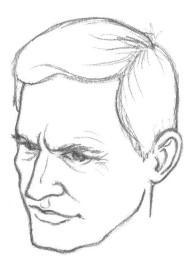

FEELING FOR FORM

For some subjects or viewpoints you may prefer to draw in a more free-flowing, intuitive manner, with the minimum of measuring proportions or angles. Some of the best drawings come out of such an approach, which allows you to feel free and unrestricted. Let's look at this approach applied to a stuffed hippo in a museum.

30

► A couple of quick sight-sizing measurements helped to establish the sizes of the main masses. Certain viewpoints can result in unexpected distortions of proportion, so it's usually worth a quick check. Here, for example, my measuring told me that the mass of the head was virtually the same size as that of the body.

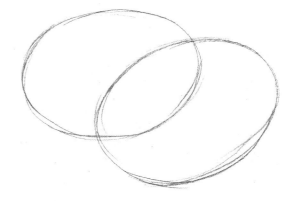

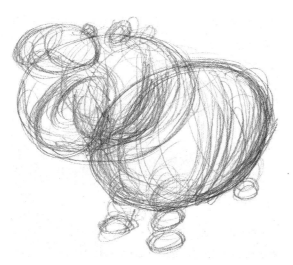

◄ Working very freely in bold circular movements, I allowed my pencil to wrap around the various masses that make up the subject, adding knees and feet, jaws and lips, eyes and ears, making nothing too definite. Already the drawing has a sense of solid form that would take much longer to produce with a more cautious approach.

► Somewhere inside the myriad lines the subject was lurking. The task at this stage was to develop the good lines and define the shape. I switched to a softer pencil so that the new lines stood out clearly.

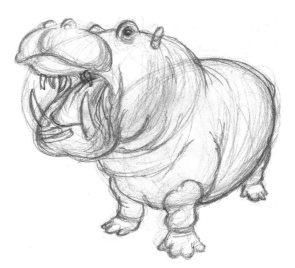

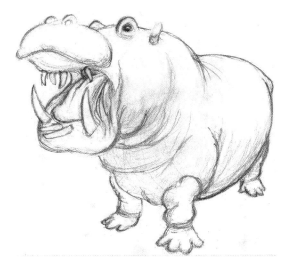

► Where the swirling marks had given the drawing a solid three-dimensional feel it seemed a shame to lose them, so I used the eraser selectively to clean up around the edges and erase those marks that crossed over awkwardly, leaving those that follow the curving form of the hippo.

▲ With a soft pencil, I redefined the contours and details. I also added to the curving lines that describe the solid form, which resulted in a drawing that looks as if it's lit from above.

RECEDING ANGLES

You can't get very far in drawing solid objects before you need to consider the angles at which lines recede from view. This is the basis of what artists know as perspective drawing. Perspective can seem quite daunting, but in essence it's quite simple to show by means of a few devices that help us to make sense of a three-dimensional view so that we may draw it on a two-dimensional surface.

▶ This drawing started with a very quick assessment of the proportions of the group and the masses within it, sketched in lightly. I used the pencil to check a rough measurement or two.

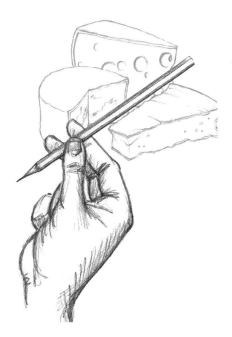

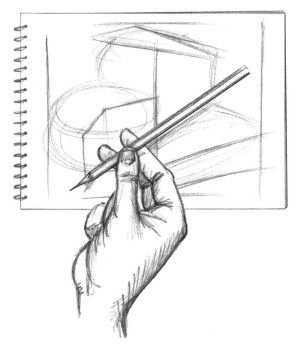

▲ ▶ Next, in order for the various blocks of this subject to look as if they sit convincingly on a surface, some fairly accurate assessment of the angles was required. Again the pencil could help. When you try this for yourself, keep it in mind that it's essential that you do not tilt the pencil backwards or forwards – it should move in a single plane, left or right, as if placed against a sheet of glass. This mimics the flatness of the paper onto which you will transfer the angle.

► Assessing, drawing and rechecking with the pencil, I soon had all the main angles drawn onto the masses.

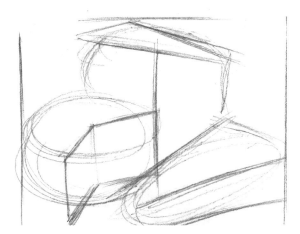

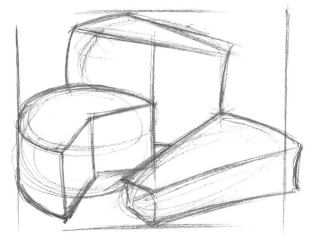

◄ With a little more observation and some checking of proportions, the main shapes of the cheeses were quite easy to draw around the angles already established. Here we have solid objects existing in three-dimensional space transferred, quite painlessly, to the two-dimensional page.

► After erasing guidelines and errant marks, it's a pleasure to refine the outlines and add details that give the objects their individual characters. Always look carefully at the subject and try to avoid making any assumptions about what a familiar item may look like.

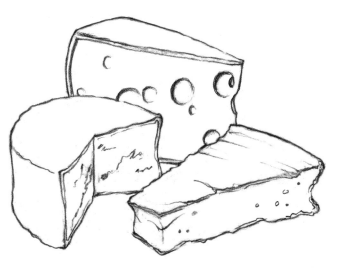

ARTIST'S ADVICE

Precision in form and dimension isn't essential for convincing drawings – if you make one element longer, fatter or more wrinkled than the reality it won't usually show in the drawing. However, if the angles of recession are badly assessed, objects appear to tilt and the drawing may suffer badly.

PERSPECTIVE THEORY

Unlike randomly placed wedges of cheese, much of our world is ordered into parallel lines and right angles, which makes drawing them relatively easy when you have mastered the rules that govern their appearance. The concepts of perspective are quite simple to understand and incredibly helpful.

NO PERSPECTIVE

This quick sketch involves almost no formal perspective at all. Seen square on, an object presents a single face that requires little analysis to draw. All the main lines of construction are either vertical or horizontal.

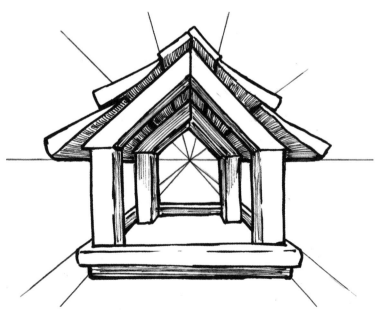

ONE-POINT PERSPECTIVE

From this angle of view, all the lines on the front-facing planes of my bird table remain vertical, horizontal, or at the 45-degree roof angle. But as we look beyond the front plane, into the interior, we can see the lines that run into the distance, which are at very different angles to each other. However, they can be seen to converge at a single point in the distance – the 'vanishing point'.

THE HORIZON

The landscape in this sketch is very flat, which means that the horizon is absolutely on the level with my eye line. You can see that the hedges to the left were slightly taller than me, and those on the right were slightly shorter. Likewise, the trees and the child take their natural height relative to my eye line.

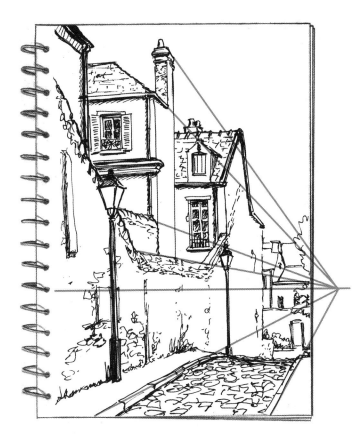

THE VANISHING POINT

The vanishing point is to be found on the horizon, directly in front of my line of sight. By taking a vertical line down from the vanishing point, you can tell that I was standing on the right-hand side of the lane.

The vanishing point won't always be in the picture. In this sketch you can see that the receding lines converge at a point off the edge of the page. This makes the view seem less formal. I didn't mark any strict perspective guidelines to do this drawing but kept the approximate placement of the vanishing point very much in mind as I assessed the receding lines with the out-held pen.

TWO-POINT PERSPECTIVE

Looking at things from more of a three-quarter view means that both surfaces recede into the distance, requiring a second vanishing point, or 'two-point perspective'.

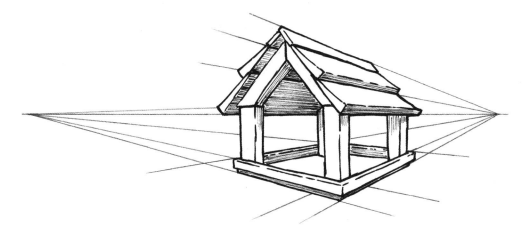

▲ For this diagram, I stepped to my right, exposing the side as well as the front of the bird table. Thus my original vanishing point also moves to the right, further along the horizon, and way over to the left another vanishing point helps us to comprehend the recession of the front plane. Yet all vertical lines remain strictly vertical.

► With this warehouse I employed two-point perspective in quite a loose way. After mapping out the main masses, I observed my eye line and marked it as a horizontal line. Then I assessed a sampling of the receding angles with my out-held pencil and roughly marked them on the drawing.

◄ I extended the initial sampling of angles to form a kind of rough grid over the drawing. I did this all freehand, without rulers and without a clear location for the right-hand vanishing point, far off the edge of the page.

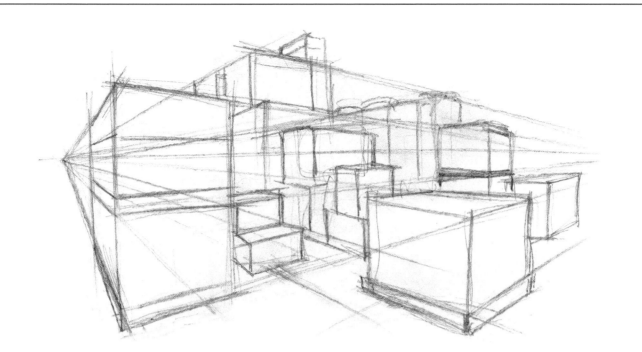

▲ In the crudely constructed grid, I could then mark out the clear shapes of the various bundles and boxes in the warehouse.

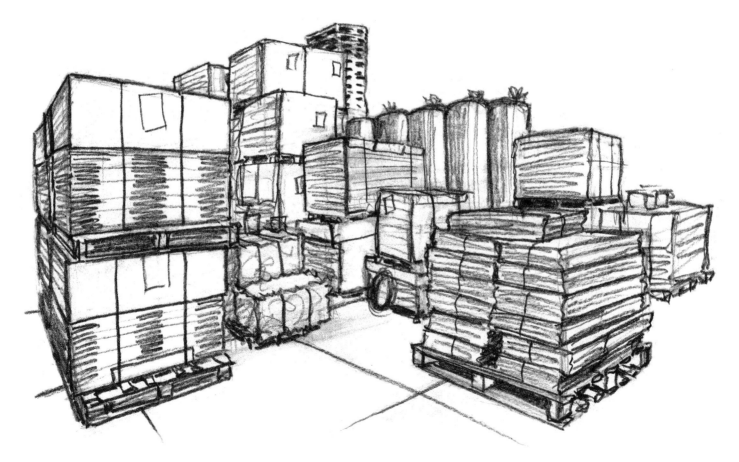

▲ After erasing the rough lines of the perspective grid, I switched to a softer pencil. With all the real drawing done, I merely had to sharpen up the outlines and add a little detail here and there.

PERSPECTIVE IN PRACTICE

◄ For this sketch I stood quite close to the buildings, which placed my main vanishing point (on the left) very close to the edge of the buildings. The result is very steep lines of perspective and a feeling of involvement in the scene.

▲ The buildings here were further away from me so my view was more oblique. This placed the main vanishing point (the right) a long way over, resulting in shallower angles of perspective and a more detached feeling. With the vanishing point so far off the page it would be folly to struggle with a precise perspective grid, so I judged all the angles by eye. As long as you maintain a degree of consistency across the drawing, perspective does allow some room for imprecision.

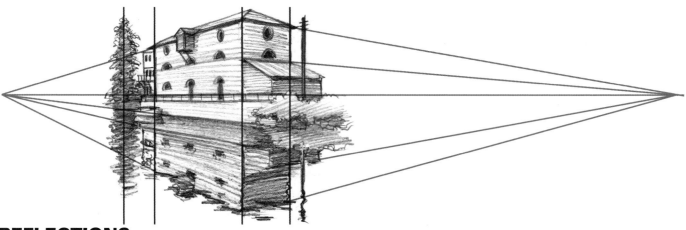

REFLECTIONS

To draw something reflected in water, all the vertical lines carry on downward to remain vertical in reflection and run to exactly the same vanishing points. It may help you to think of the subject and its reflection as a single mass.

CURVES

Not everything is composed of entirely straight lines and you'll soon come across the problem of drawing circles, arches and other curves in perspective. So let's draw an arch, starting with a simple perspective rectangle. To find the apex of the arch we need to find the centre line, which is done by marking a cross from corner to corner and then taking a vertical from the centre.

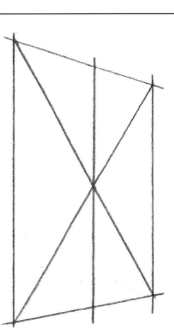

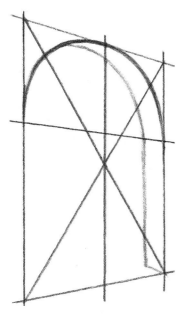

◄ Mark the bottom extent of the curve and strike a line to the vanishing point so that the level tallies with the opposite side. Thus we have the two equal quadrants clearly marked and a smoothly flowing curve can be drawn within the guidelines. To show the thickness of the arch, draw another line inside that follows the contour of the outer edge.

► Here we have arches within arches. It's a simple drawing, but it would have been very tricky without the theory of perspective curves. Note that the arches are constructed off different vanishing points, depending on their orientation.

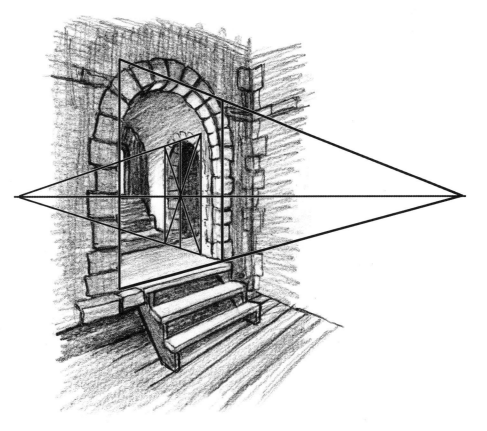

SHAPES IN PERSPECTIVE

Elementary perspective turns out to be useful for drawing all sorts of objects, not just the obviously geometrical ones. Here we explore the perspective box as a very useful device for getting to grips with the structure of all sorts of drawing challenges.

► I did this tiny sketch with a ballpoint pen and no pencil guidelines. It wasn't especially difficult because the vehicle is essentially box-shaped. Once I had established the basic dimensions and angles, all the detail could then be fitted into the scheme.

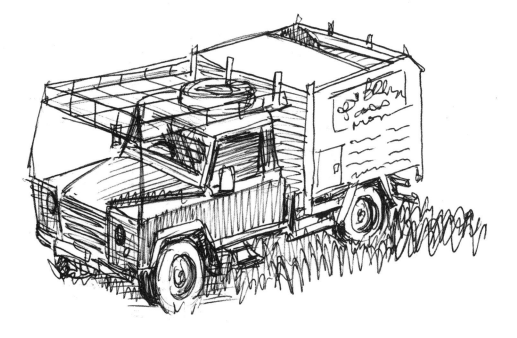

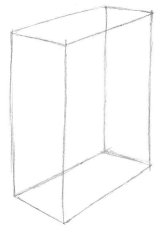

► Construct a box following the rough proportions of the object you want to draw. With some quick angle assessment and common sense, you shouldn't find it necessary to draw vanishing points and receding lines.

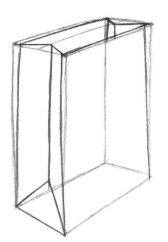

◄ The box may now be tailored to suit the particular subject. This paper bag had sides that sloped in at the top, so I redrew the uprights to lean inwards. Another guideline dictates the centre line of the bag's opening, which helped me to draw the folding sides of the bag.

▶ Now it was no longer necessary, I could erase the original box. To draw the handles, I then constructed another box, this one following the slopes of the bag. The box form allows the handles to be placed symmetrically on both sides of the bag, maintaining a uniform height.

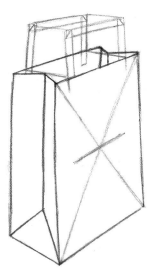

◀ I could now draw the handles confidently. To find the centre of the bag, for a logo, I marked diagonal lines from each corner.

▶ Finally, I erased all the guidelines. The end result was a strong, simple drawing.

▲ You'll soon find that you can draw all sorts of objects from different angles so long as you can draw the initial boxes in reasonably correct perspective and use the appropriate guidelines. This guitar, for example, needed a strong centre line on its front face and definite guidelines for the upper and lower curves of its body.

THREE-POINT PERSPECTIVE

Generally, two-point perspective is sufficient for most subjects and viewpoints, but there is a third point that comes into play when you're looking sharply up or down at a subject. It can be used to varying degrees and it's worth taking on board because it can be subtly effective or quite dramatic in use.

42

► Returning to my bird table, I drew it from a lower viewpoint, effectively looking up at it. This means that the upper parts are further away and so the upright lines will naturally recede into the distance, meeting at a point high above. This diagram is rather exaggerated; the angles wouldn't normally be so steep unless seen from very close up.

◄ In most cases, the presence of a third perspective point doesn't require much more than a general awareness of it as you draw. Horizontal lines of recession are usually far more evident, as demonstrated by this farmhouse. The vertical sloping is quite subtle, but it's quite important to the elegance and naturalism of the drawing.

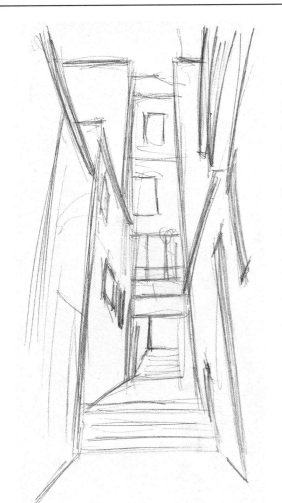

◄ The overhead perspective point is more evident here, but the drawing was hardly more rigorous. As the initial guidelines show, all that was required was a few main guidelines roughly judged and marked and the rest of the angles fell into place in the drawing process.

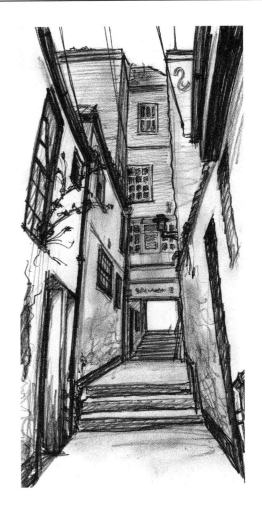

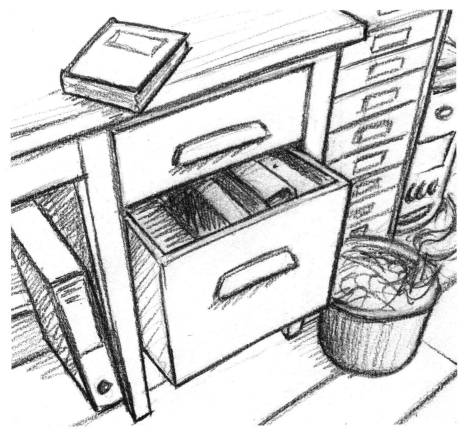

◄ Three-point perspective isn't restricted to things towering over our heads; it's more likely that you'll use it for looking down on smaller subjects. The closer to the subject you stand, the more exaggerated the angles will be.

ARTIST'S ADVICE

Choosing subjects where the angles aren't precise, such as rickety old buildings, means you can take a very loose approach to perspective and any odd discrepancies will only add to the subject's charm. In such cases you can avoid too much concern with the technicalities of perspective and enjoy drawing freely.

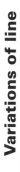

VARIATIONS OF LINE

It won't have escaped your notice that the drawings shown so far have
demonstrated some variation in the way that the lines have been formed.
Now we'll look into this matter further as we delve into the area of mark-making.
Your choice of pencils or pens inevitably affects the outcome of a drawing, but
the marks you make will also depend very much on how you use your materials.

44

► For this one-
minute sketch I used
a marker pen and
concentrated only on
setting down the angles
and proportions of
the figure. The heavy
line lends solidity to
the pose, but little
sensitivity.

◄ With the more sensitive
medium of pencil, I aimed
to capture a sense of
the thrust and tensions
within the pose. Again,
I stuck to a one-minute
time limit, which
inspired me to use
direct, unbroken
and unfussy
lines, lending
dynamism to
the figure.

◄ Shorter, scratchy
strokes of the pen
bring out the angular,
knobbly qualities of
the older physique.
The pose still has a
thrust to it, but the
feeling is less graceful.

▼ To sketch this old chair, I allowed the pencil to spiral around the curves and mouldings, aiming to replicate its dilapidated, baroque qualities.

▼ This chair is similarly old and wonky, but quite different in its structural feel. Here I sketched with firmer, straighter lines, contrasting with the curving lines of the rucksack hanging from it.

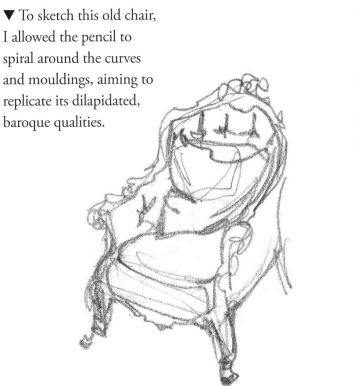

▼ On a sketching trip to a regional museum, I set myself the challenge of drawing a number of sculptures, carvings and masks using a very different style of line for each one. I aimed to be sympathetic to the character and material of the subjects as well as tapping into the feel achieved by the craftsmen who made them. Such studies make excellent practice for identifying and developing your own artistic style.

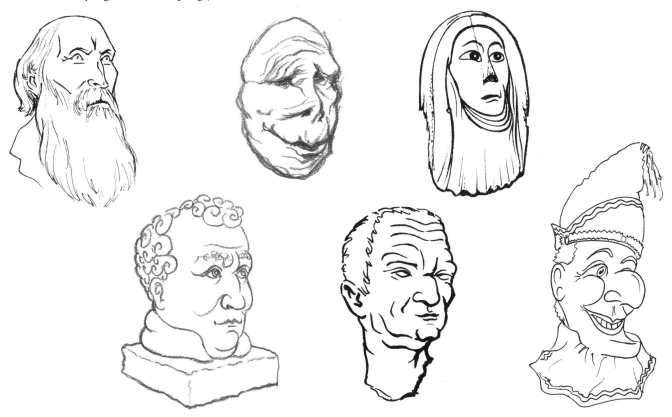

INTRODUCING TEXTURE

In drawing with a conscious approach to mark-making, we naturally start to imbue our subjects with a sense of the surface, or texture, of the materials from which they are composed.

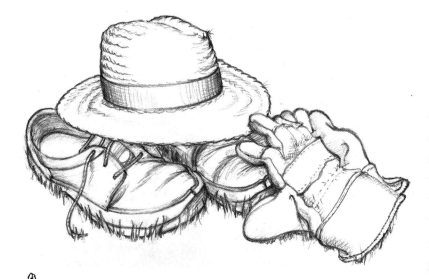

◄ In this study I strove to show something of the particular textures of the various objects: the woven straw of the hat, the soft suede of the gloves and the rigid leather of the shoes. The outlines do most of the work, complemented by some minimal shading and detailing. The ground, although barely drawn at all, is clearly a grass lawn, indicated by the mere suggestions of its texture along the bottom edges.

◄ The shapes and angles of many subjects can be interesting enough in themselves to make worthwhile studies, but sometimes the addition of varied textural marks can enhance their character and charm. With the pencil guidelines erased, this pen study, despite its very solid subject matter, looks quite flat and lightweight.

► It doesn't take much in the way of texture on the walls to make the buildings appear more sturdy and ancient. Similarly, the tiled roofs now look heavier and the gate more formidable. Although the lines on the gates were clearly visible, I drew them with broken lines to avoid over-inking that part of the drawing. I then strengthened the outlines of the gateposts to bring them forward against the background.

◀ Textural drawing soon becomes instinctive. In a quick sketch, without really thinking about it, I used different outlines and pencil marks to convey fluffiness, wrinkles, stiffness and weight of cloth, surface pattern and so on. The differences between the surfaces can be quite sketchily hinted at where you can rely on the viewer's knowledge of the types of clothing depicted.

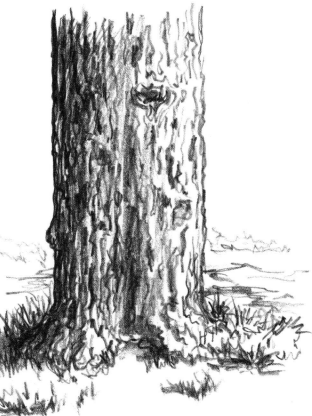

▲ As I sought out the crags and wrinkles of this careworn face, the firm marks of a very soft pencil built up a solid and characterful portrait. I used different marks for the spikiness of the hair and went over the outside edges extra heavily to soften the character lines in comparison.

▲ The ridged and pitted surface of its bark catches the light differently on each side of this tree, requiring heavier and lighter marks. Effectively, the textural treatment conveys the light and shade, giving the subject a rounded, three-dimensional look.

LIGHT AND SHADE

Just as mark-making leads to texture, so texture brings us on to tone. 'Tone' is the technical term for the range of lights and darks that make up a picture. It may refer to the inherent darkness or colour of an object, known as its 'local tone', but more usually it's used in relation to the description of light and shade.

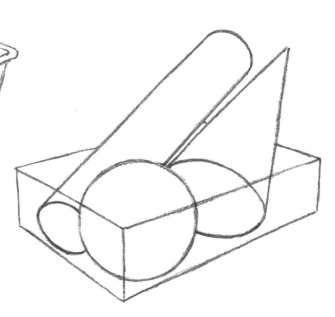

▲ As we consider tone it may be helpful to recall Paul Cézanne's advice to see nature in terms of the cone, the cylinder and the sphere. He asserted that at a basic level any natural object can be broken down into these shapes, and the punnet of fruit offers some quite literal examples.

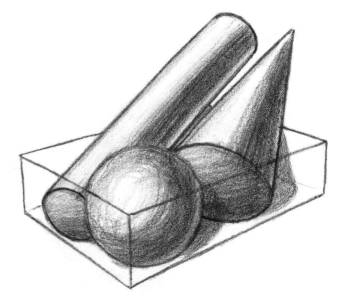

▶ With shading introduced, you can see that each shape takes on undeniably solid form and the whole assemblage exists in spatial depth. From the lack of textural marks, you can also detect that the shapes are quite smooth and featureless.

However, what's most interesting at this stage is that each form has its own shading pattern: straight for the cylinder, converging for the cone and curved for the sphere.

► Here the same shading patterns are adapted to natural forms. The areas where the light bounces off an object towards the viewer, making those areas brightest, are called the 'highlights'; the 'local tone' is the tonal value of the objects' inherent surface colour; the areas that face away from the light source and appear dark are termed 'shade'; 'reflected light' describes light that bounces back off the surroundings and partially illuminates shaded areas; and 'cast shadow' results from one element blocking the light from another.

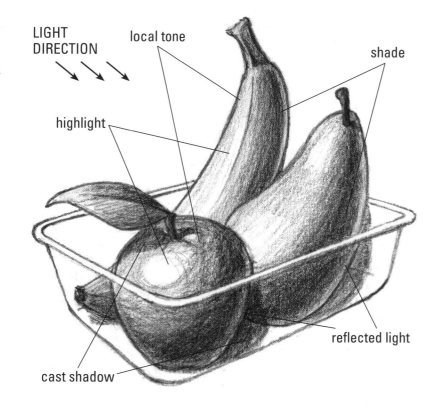

LIGHT DIRECTION

local tone

shade

highlight

reflected light

cast shadow

◄ The shading on this cone and cylinder follows the expected pattern described by Cézanne's shapes and also explains the different textures of the surfaces. Tone and texture are very often dealt with in the same stroke of the pencil.

► Here's another conical plant, but this one is composed of lots of spherical masses and is shaded accordingly. The trunk, though cylindrical, starts to divide near the ground, requiring it to be treated like two conjoined cylinders.

SHADING AND HATCHING

The methods of drawing in tone are many and varied, and may depend on the subject, lighting conditions, materials, personal style and so on. Nevertheless, they mostly boil down to a few essential processes, which we shall now examine.

► Here I've completed the outline drawing in pen and also worked some texture into the wooden chopping block. The axes look decidedly lightweight in comparison.

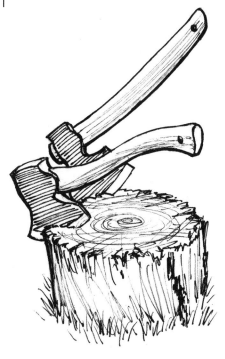

◄ Next I described the axe handles with a few very light textural strokes. With a smooth outline, this reads more as wood grain than rough texture. The heaviest part of the subject is the axe heads, so I started working those with bold, evenly spaced, parallel pen strokes.

► To complete the axe heads, I worked over them again in just the same way but changed the direction of stroke. I stopped short of the upper edge, where they are lighter in tone. Repeating the action in a third direction builds up the required density of tone.

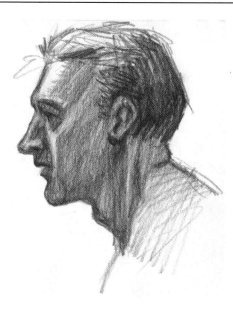

◄ If you look closely you can see evidence of the hatching technique in this portrait study. I used a coloured pencil (a dark, neutral colour) and rendered the face in many different directions so that the hatching blends together, but there are subtle modulations within the tone that are most easily achieved with the hatching method.

► All the shading here is done in straight lines radiating from a point above the subject, thereby making a feature of the direct overhead light source.

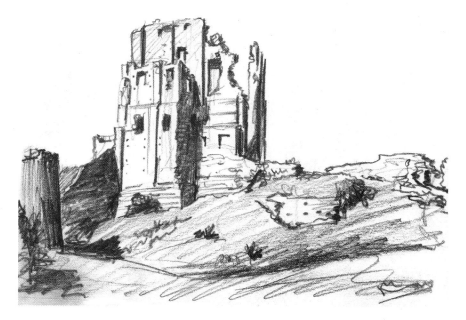

◄ Here the pen lines follow the form of the subject, wrapping around the various parts like contours and helping to describe the solidity of the sculpture.

► There are several approaches of rough shading in this sketch, most notably in the lines that make up the castle ruins. Variations in the weight of line suggest the shadows cast by the light relief of the castle walls. In other parts the tone is scribbled loosely with the point of the pencil or, for the softer marks, with the broad edge of the pencil used on its side.

CHARCOAL

So far we have concentrated on pencils and pens, but there are many other materials that offer different drawing effects, especially in terms of mark-making and shading. One such material is charcoal, which is nothing more than charred wood and can be bought very cheaply in sticks of various thicknesses.

► This tiny sketch demonstrates the strong dark line and soft-edged, smudgy qualities for which charcoal is known. Working at speed, I roughly scribbled in the darker patches of sky and then smudged them around with my fingertip. Over this background layer, I could then draw the line of trees and bushes with the tip of the charcoal stick, before hurrying away to avoid the rain. Back at home, I used a piece of white chalk to pick out the highlights in the clouds.

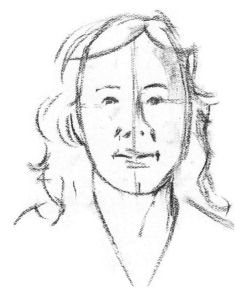

◄ To demonstrate the basic techniques for using charcoal, I sat a friend by a window for an even side light and roughed out the main features and proportions of a portrait with the tip of a broad charcoal stick. Using paper with a lightly textured surface helps to abrade the charcoal as you work and allows for repeated reworking of the drawing.

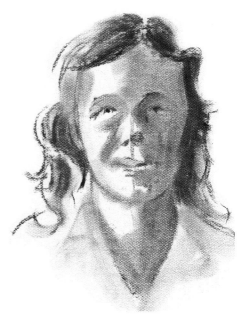

► I broke off a short length of charcoal, about 2.5 cm (1 in) long, and used it on its side to quickly cover all the areas of shade in broad strokes, pressing harder for the darker parts of the hair. I then softened the skin tones by smudging with a finger. At this stage I wasn't concerned with any details, just the broad masses of tone.

► With the tip of a thinner charcoal stick, I set about drawing the features and the main tones of the hair, with careful attention to the model.

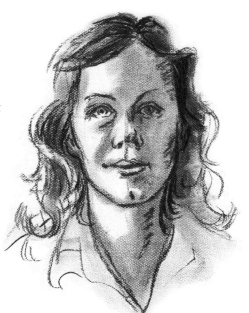

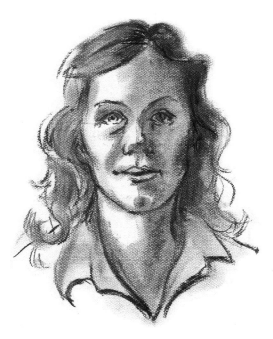

◄ Carefully and selectively, I blended the tones further with the very tip of a finger, trying not to smudge too much detail in the process.

► Taking a soft eraser, I cleaned up the grubby marks in the white areas and used the corner to pick out some highlights. I also worked some detail into the hair, with more line drawing and some erased highlights to give it some shine.

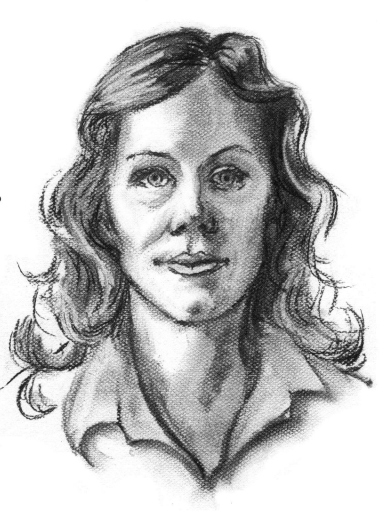

ARTIST'S ADVICE

Spray charcoal drawings with artists' fixative spray to make them more stable when they are finished. Hair lacquer does quite a good job too for a fraction of the price, though it can slightly yellow the paper in time.

AERIAL PERSPECTIVE

Now that we're getting to grips with tone, it's a good time to introduce the idea of tonal contrast. Mastery of the contrasts within a picture is another way to control the illusion of spatial depth, so it's considered a form of perspective.

The basic principle of aerial perspective is that as a result of the mass of air, dust and moisture creating haze in the atmosphere, tonal contrasts diminish over distance. So objects drawn with dark lines and shadows and bright white highlights will be read by the eye as being in the foreground, whereas faint marks in shades of grey imply something in the far distance.

54

▶ Although all the marks here are black on white, the weight of the lines creates the sense of contrast. Foreground features are outlined and textured heavily with repeated marks of a fine drawing pen. The middle ground is drawn with less heavy marks and the buildings in the far distance are indicated with light, broken lines and minimal texture.

◀ The addition of tone, applied with a soft pencil, further enhances the feeling of depth from foreground to background. I worked the pencil as dark as possible to make deep shade and shadows around the water and columns, but stroked only a faint flat tone over the far buildings to give them some form.

► Aerial perspective is best observed in hazy or misty conditions, which exaggerate the effects. Here the landscape, sketched in charcoal, appears as layers of tone, growing increasingly faint into the distance until the land is hard to distinguish from the sky.

◄ This little charcoal and ink sketch relies on the outlining for its depth. Heavy brush and ink details in the foreground sit forwards of the finer outlining in the middle distance. The background church has no black outline, existing as shades of charcoal grey. The heavy grey sky further reduces its tonal contrast and sets the scene in atmospheric twilight.

► Some of the darkest tones in this drawing are to be found in the far distance. It's not always paleness that pushes things into the distance; it's the contrast relative to the foreground. With no brightness in the depths of the woodland, its contrast is low compared to the foreground trees.

TRANSPARENT MEDIA

As your drawing skills increase in competence and sophistication you'll want to expand your repertoire of techniques to take in other types of media. One technique, very different from the charcoal we've just explored, uses transparent glazes or washes to build up tone and texture in layers that may be easily controlled.

56

▶ The most common and versatile of transparent materials is watercolour. To portray subjects such as this restaurant interior, watercolour is appropriate for its bright, clean tones of subtle modulation.

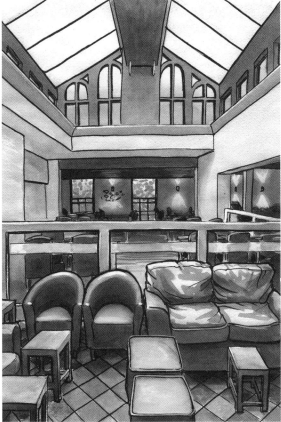

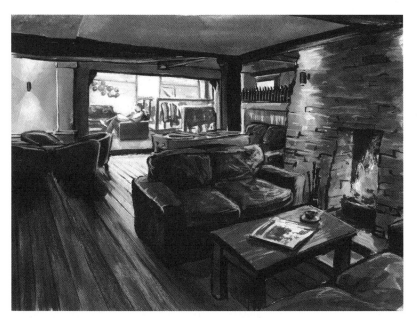

◀ This different view of the same building required a heavier feel, so I used the dense darks of ink in various dilutions.

BRUSHES AND PAPER

It's well worth buying good-quality watercolour brushes, even though they are expensive. I recommend round, soft-haired brushes of sable/synthetic blend. Sizes 3, 6, and 9 would make a good starter set, but one brush of size 6 should be versatile enough for most uses as long as it has good fine point.

Any liquid medium will soak into and stain your paper. Thin paper will tend to buckle with the moisture, so use thicker paper – around 200gsm (120lb) should be sufficiently heavyweight.

BASIC TECHNIQUE

As with any media, there's no right or wrong way to use watercolour or diluted inks, since different subjects will often demand different treatments. Nevertheless, it's useful to look at some stages a layered rendering might typically go through. I selected a simple subject with strong directional lighting and drew a clean outline faintly, including the shape of the shadow.

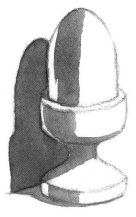

Shade

Mix a little black watercolour or ink with some water on a flat white surface such as a china plate – you need enough liquid to charge and recharge a medium-sized brush easily. Use a scrap piece of the paper you'll be painting on to test the tone of the mixture. Then paint the main areas of shadow in quick motions, allowing the paint to saturate each flat area before moving on to the next. Don't fiddle; once the paint or ink is applied it shouldn't be touched again until dry.

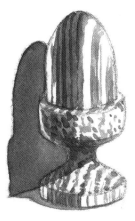

Texture

When the shade is dry, the texture and markings can be applied. Make a slightly richer mix and use the very tip of the brush to draw the wood grain around the acorn and the puckered texture of its cup. Wooden objects make for good practice because most mistakes can be hidden within the wood grain.

Local tone

Mix up plenty of light tone and wash it over the entire acorn, cup and cast shadow in swift, broad strokes, taking care to leave it bare where you want the highlights to be. If you go over the edge, or paint into a highlight, the pigment can be lifted off by dabbing with tissue paper.

Fine tuning

To finish, use a dark wash to state details of extra-deep tone and refine details of texture. The temptation may be to overwork the detail or to apply more layers of subtle tone, but wash drawings nearly always work best when left simple and bold.

SKETCHING WITH WASH

There's a big difference between drawing in the comfort of the home to make finished pictures or studies and sketching while out and about. In the latter case we tend to ignore a lot of technical process and do whatever is necessary or possible within the limitations of our circumstances. This is often the case when working in wash.

58

◀ Over minimal pencil guidelines I drew the main features with a drawing pen, adding some occasional textural marks but no shading.

▶ With a well-loaded brush of very diluted ink I blocked in the main masses of the shed, cliffs and the upper part of the sky. Washes dry very quickly outdoors, so I was soon able to work some details into the cliffs and foliage with a second layer.

ARTIST'S ADVICE

If you plan to use washes over an ink drawing, make sure that you use a pen with waterproof, or permanent, ink. Watersoluble ink will smudge or wash away with the addition of wet media.

▲ I continued to build up the tones and textures in successive washes. Despite the many layers of wash, the picture retains a degree of freshness as a result of my speedy brushmarks and of leaving parts of the paper clean and white.

WATERSOLUBLE DRAWING TOOLS

Drawing pencils, coloured pencils, crayons and pens are all available with watersoluble pigment. They are inexpensive and good for quickly building up richly toned drawings and sketches.

▶ To quickly capture something of the voluptuous solidity of the model, I used a watersoluble pencil just as I would an ordinary pencil and roughly scribbled the broad areas of shade. Then I dipped a stiff brush into some water and painted it over the pencil tone, effectively turning it to paint, allowing me to blend the tones.

▲ I roughly drew and shaded my old shoes in dark grey watersoluble crayon before painting water selectively over the surface. Once it was dry I added some dark accents with brush and ink and some highlights with a white crayon.

▲ The dense black marks of cheap felt-tip pens can be transformed into a range of greys when selectively moistened, softened and spread around with brush and water. The very instability of the wet ink forces you to work quickly and without fuss.

ARTIST'S ADVICE

It's good practice to leave highlights untouched throughout. No amount of white paint, pencil or chalk will produce a highlight as crisp and pure as that of virgin white paper.

BRUSH DRAWING

The paintbrush isn't merely a tool for applying and blending tonal washes – it can also be a very effective drawing instrument in its own right. The most common medium for brush drawing is black ink, and a small bottle of drawing ink or acrylic ink will last a long time. Make sure that you use ink that is waterproof otherwise any further addition of wash will blur your original drawing.

60

▲ While the portable drawing pen has many practical benefits, it won't always be the most suitable tool. A fine watercolour brush produces lines of varied thickness resulting in more graceful, flowing marks that may better convey the spirit of certain subjects.

► Brush and ink is useful to give a deeper shade of black beyond the limits of even the softest pencil. It can be used to bring order and accents to very rough sketches, as in this tonal study.

► Different types of brush produce different types of mark. A stiff brush leaves characteristic traces of its bristles, used here for the model's shiny hair. The fine textural marks were made with the brush dabbed semi-dry on tissue paper, a technique known as 'dry brushing'. This drawing also demonstrates the brush's capability to effortlessly cover the paper in solid black.

◄ A bottle of ink is not the easiest thing to handle when sketching out and about, but you can achieve similar results with a felt-tipped brush pen. I did this drawing on location, first drafting very loose guidelines in pencil and then switching to a brush pen for the rest of the work. The flexible tip is capable of many varied marks, which I exploited here to differentiate between all the various textures and surfaces.

TONAL BRUSH DRAWING

For most line drawing, a round watercolour brush in medium size (such as No. 6) with a fine point will suffice. A little doodling practice on scrap paper will accustom you to the feel of the brush and the flow of the ink.

The following exercise involves a range of marks that depend upon the angle of the brush and how much pressure is applied. The drawing is based on a rough sketch of a real scene, but feel free to change any details if you wish to as you follow these basic steps.

62

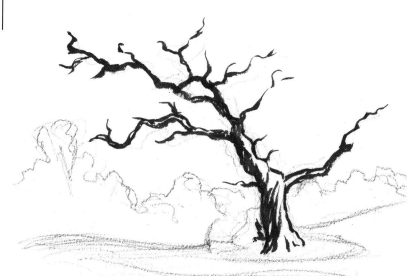

◄ Here I used a small off-cut of textured watercolour paper (about 20 × 15cm/ 8 × 6in), on which I drew a few bare lines of pencil to establish the basic composition. With black waterproof ink, I then drew the trunk and main limbs of the tree. A few strokes were sufficient to indicate the shade and texture on the trunk.

► With the very tip of the brush I drew in the smaller branches and a little outline detail of the trees in the background. (Note that this particular tree is old and dying; a healthier example would have many more branches and twigs.)

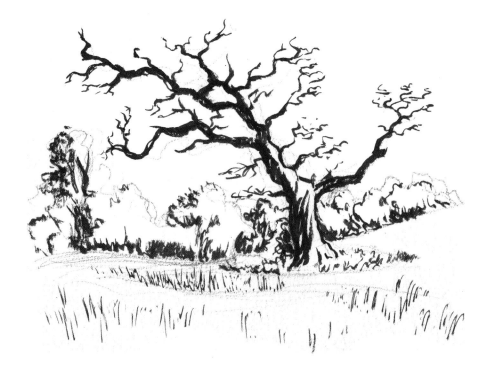

◄ After adding a few strokes in the foreground to suggest the crops growing around the tree, I partially dried the brush on some tissue paper. With the brush semi-inked, I roughly scumbled some textural marks in the background and also on the trunk of the main tree.

► I dipped the tip of the brush into some water and, in an old saucer, I worked the water into the brush for a slightly diluted mix with which to block in the distant tree shapes. As I dabbed the end of the brush on the paper its hairs splayed out slightly, allowing me to add loose leaf-like marks for the oak's depleted foliage.

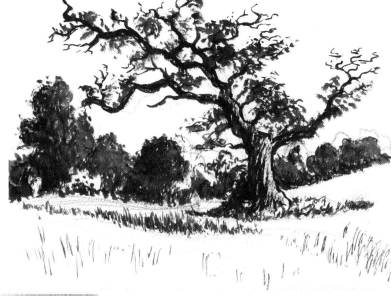

◄ I mixed more water into the ink in my saucer to make it much more dilute. With a larger brush I washed some tone over the field and sky in swift, confident motions. I then used a clean tissue to dab off the areas I wanted to remain white or pale.

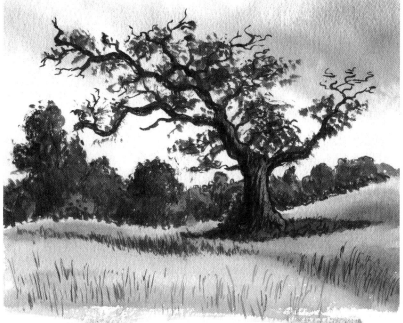

MARKER PENS

Offering some of the qualities of watercolour and inks, two or three artists' quality marker pens could be a useful addition to your kit. They are quick and versatile to use and also have their own unique qualities that are worth experimenting with.

▶ Much like washes of watercolour or diluted ink, marker pens can be repeatedly applied to build up depth of tone. This little study used a single pen of pale grey.

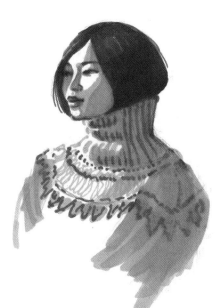

◀ Introducing a second tone makes for richer tonal contrasts. The stark difference between two shades of grey can be softened by working the lighter pen over the darker marks, seen here in the patterns and textures of the pullover.

▶ Where marker pens really prove their worth is in their blending capabilities, which can give a look of slickness to even quite rough drawings. I did the loose outlining here with a black felt-tip brush pen and filled in the areas of very deepest shade as solid black.

I used three shades of grey marker to build up the tones, starting with the darkest, filling in broad areas. The hard edges don't matter because they will be softened with subsequent paler layers.

▶ With my medium-tone pen I covered areas of mid-tone. Where I met the darker tone, I worked the mid-tone pen into it, thus roughly blending the tones into each other.

◀ With a third, paler grey, I worked over the entire car, paying special attention to the areas of graduated tone to blend them smoothly.

▶ When working vigorously and aiming at a fresh, loose feel, it's not always possible to avoid getting ink over the required areas of highlight. However, they can be applied on top of the artwork using an opaque white medium. Here I used white drawing ink and a fine brush, working in swift strokes to retain the carefree flavour of the line and tone drawing.

ARTIST'S ADVICE

Oil and water don't mix, so spirit-based pens won't affect a drawing done in water-based ink. In this respect the choice of material for highlights may be important. If in doubt, do some tests beforehand.

OPAQUE MEDIA

On the previous spread you saw how white ink could be employed to put in highlights on top of darker marks. The dense covering power of opaque materials allows you to draw light over dark in various ways for various effects. Different materials have their own characteristic marks and differing degrees of opacity.

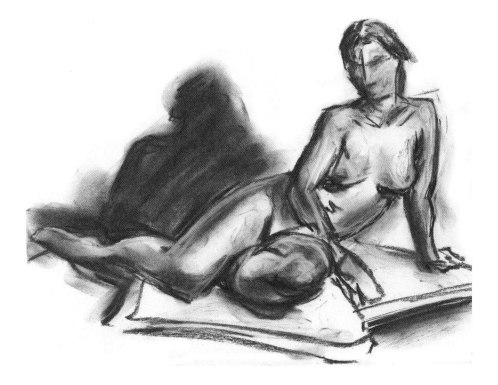

◄ Here I used a dark grey pastel for the main drawing, smudged here and there with a fingertip. To add the highlights, rather than carefully trying to erase back to the white paper it's quicker and more sensitive to use a white pastel over the top of the dark drawing. The two tones can be blended by smudging, if required.

TONED PAPER

Working on grey or black papers, or 'toned grounds', allows for clear and dramatic use of opaque materials, as this sketch demonstrates. It took no more than a minute to roughly paint on the highlights with white ink, yet the result is quite dazzling compared to the earlier stage.

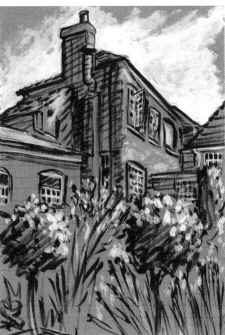

► With mid-tones already established by the paper, you can concentrate on the lights and darks and draw with economy, resulting in quicker, cleaner drawings. White ink applied with a thin bristle brush over a sketchy ink wash drawing leaves bright highlights that economically describe the model's outer contours.

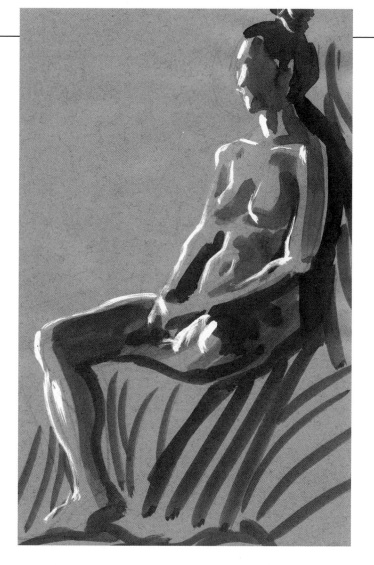

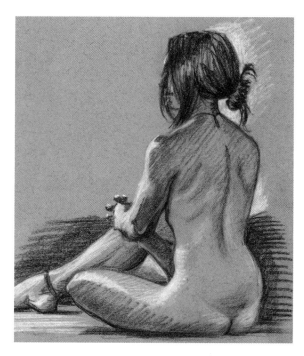

▲ Pastel pencils produce a delicate, pressure-sensitive mark, well suited to hatching subtle shades and tints. The white is not so bold as in other materials; strength of opacity must often be sacrificed for sensitivity.

> **ARTIST'S ADVICE**
>
> **When working on toned grounds, it's often a good idea to leave a generous amount of the surface unworked, with the ground tone showing through.**

▲ On toned grounds, a drawing may be done entirely in white or pale opaque material. This can be especially effective when working on very dark paper with subjects of bold lighting or tonal contrast, such as this pastel study.

PART II: *Seeking essential truths*

Just as important as what you draw is how you draw it, and yet even more essential is what you don't draw. No drawing can hope to comprehensively include the full breadth of our penetrating vision – every blade of grass, every pore of skin, every fluctuation of light or modulation of tone – but in any case much more can be achieved by intelligently restricting the scope of our drawings. Any subject embodies many different qualities; an apple may be simultaneously round, solid, shiny, green, blemished and so on, and it's up to you as an artist to decide what you want to convey. And it turns out that the less you try to cram into a drawing, the more interesting it will be.

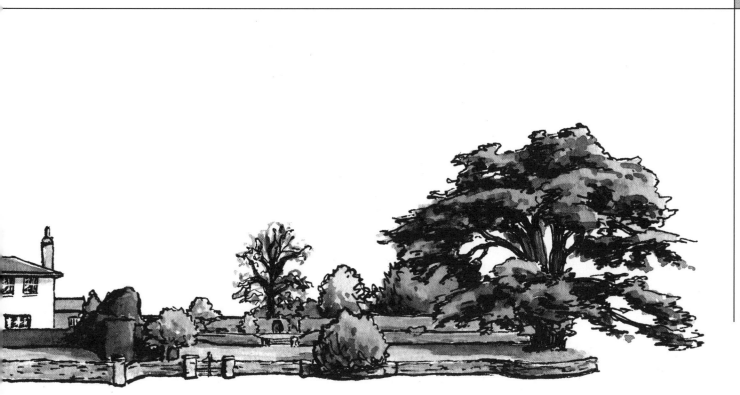

So, we begin part two of this book with exercises in self-imposed restrictions. It may sound contradictory, but placing restrictions on your working practices is actually very liberating and will quickly develop your creative instincts. We shall look at the practical limitations of sketching beyond the comforts of home, experience of which will inform your working practices and encourage you to use your tools and materials with efficiency, playfulness and individuality. These lessons will lead you into the real work of distilling your subjects into drawings of elegant simplicity.

Rather than slavishly copying every aspect of a subject, we shall instead seek to convey single essential truths. Different subjects will naturally suggest certain treatments or experiments, always with the clear objective of illuminating their particular physical and emotive qualities, so various methods and materials will be further explored and demonstrated throughout. Interesting drawings will inevitably result and you'll discover that from simple aspirations can come drawings of expression and effectiveness.

FRAMING AND SELECTION

As you progressed through the first part of the book you will have noticed that the drawings increasingly included background features or tone, resulting in them spilling beyond the clear boundaries of a subject's outline shape. In other words, the pictures were beginning to fill rectangles. So at this point we must consider the extent of a drawing's edges, or 'framing', and the effects that such decisions may have on our drawings.

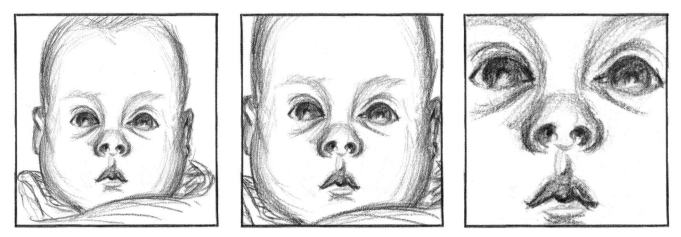

▲ Here are three versions of the same sketch. The features and expression of the baby are the same in each, but the closeness of the framing lends each a different feel. As is often the case, including less in a drawing can actually increase its impact.

▲ Selecting only a part of a familiar subject can make it more ambiguous and therefore more intriguing. Thus an unremarkable life drawing can take on qualities of landscape or abstraction.

▲ A similarly abstract feel is achieved by the close framing of this plant sketch. Allowing the drawing to extend to the very edges of the frame gives the drawing a crowded feel, making the plant seem bigger and more vigorous.

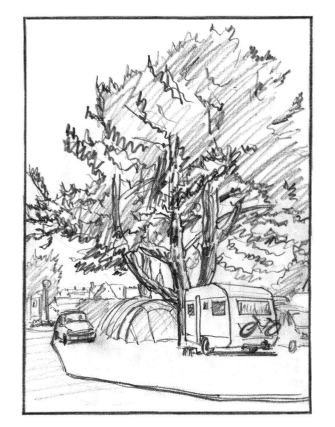

▲ A creative eye can find interest in the most unexpected places. Selecting an interesting viewpoint and an effective framing here elevates a mundane collection of drainpipes to a subject worthy of attention.

▲ At other times it may be appropriate to include more of the details around a main subject. A huge, spreading tree canopy provides a charismatic campsite setting.

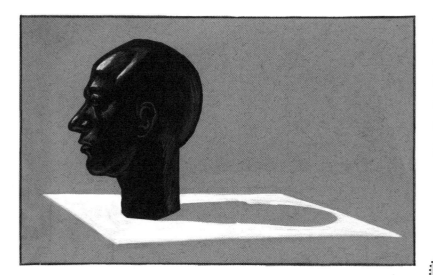

◀ Some subjects seem to need plenty of breathing space, creating a mood of dignified calm. This carved head benefits from the inclusion of its shadow, which is allowed space to be as much a part of the picture as the main subject.

ARTIST'S ADVICE

It is perfectly valid to alter a framing after a drawing is finished, by erasing, masking or even cutting off the unwanted edges.

COMPOSITION

More sophisticated considerations of framing come under the heading of composition. In art, the term refers to the organization of elements within a frame, the foundations upon which a picture is built. A clumsily composed picture will always look weak, however well drawn the details may be, whereas a strong composition will shine through the clumsiest of drawing techniques. Here are just a few tried and tested methods for achieving accomplished compositions.

▲ The most elementary composition places the subject in the centre of the frame. While this isn't very dynamic or exciting, it may suit some subjects and can look accomplished with an interesting interplay with surrounding elements. In this case the vegetables are arranged to follow a loose spiral into the pot.

▲ Invariably, though, it's more interesting to place the subject off-centre. The Ancient Greeks had a strict formula for the ideal division of a space to produce what was called 'the golden section'; some artists refer to the 'rule of thirds'. Both 'rules' suggest that satisfying compositions will result from making divisions of the frame and placing centres of interest at around three-fifths or two-thirds respectively along the horizontal or vertical dimensions of a picture.

▲ Heavy tones carelessly placed within the frame can make a picture seem lop-sided, so imagine a composition pivoting on its focal point, with the weight of tone having more or less effect over distance from the pivot, and aim to balance the whole. If this is reduced to blocks of pure tone we can tell at a glance if a composition looks tonally balanced.

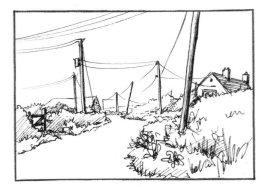

▲ A successful composition can direct the viewer's eye into a picture towards a focal point by means of directional lines. A road or river naturally leads the eye, as do other linear features, such as the hedges and telegraph poles here. If such leading lines follow graceful curves the composition will seem to flow.

ARTIST'S ADVICE

A simple viewfinder is a great help for visualizing different compositional framings. Cut out two 'L' shapes of cardboard and attach them together with paper clips to the proportions you desire. You can then hold the viewfinder out in front of you to observe a subject or scene within the limits of a frame. These 'L' shapes are also useful for helping you to decide on alternative framings for finished drawings.

RESTRICTED TONE

In drawing we can only hope to mimic about one per cent of nature's vast tonal range from total darkness to brilliant sunshine. Trying to capture every subtle modulation of tone in between is a painstaking task that usually results in drawings that are over-fussy and stiff. It is surely more fun to embrace our inadequacies and make inventive use of tone. Indeed, it often turns out that the less sophisticated the tone, the more interesting the drawing.

74

▶ For tonal drawing it's often necessary to take tight control of the tones within a picture for the sake of readability. Here I was faced with a grey bird on mid-toned branches amid generally mid-toned foliage, so I made the decision to exaggerate the tonal differences, lightening the foreground elements and pushing the background into greater tonal depth.

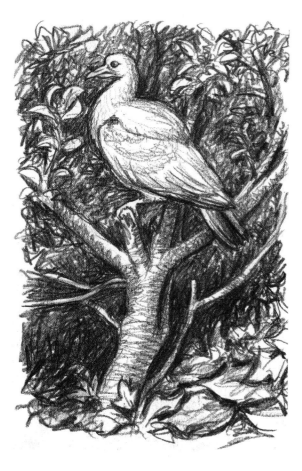

◀ Here I restricted the tones to two shades of grey marker pen. I did most of the drawing in pale grey and then added details and accents in the darker tone, ensuring that I left a good amount of white paper showing through.

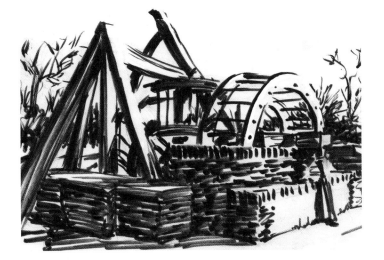

◄ When you are sketching with a brush pen, the stark blackness of the mark forces you to make firm tonal decisions. Each part of the picture must be contrived as either black or white, although the pen can be quickly grazed across the paper for rudimentary shading that acts as a grey.

► Against a snowy background in dull conditions, this branch made a naturally monotone subject. There was little interpretation required, but I did make a conscious decision to draw no outline of the snow resting on the branch, instead allowing the spaces within the drawing to make the necessary suggestions.

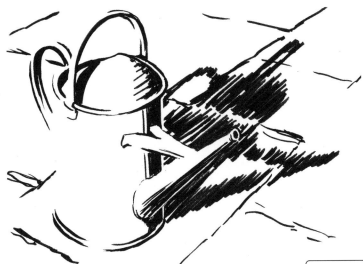

◄ It can be very effective to leave parts of a drawing unstated, allowing the viewer to mentally fill in the gaps. The trick is to draw the whole thing first so that when you do the final inking you can be sure that the drawing works structurally.

ARTIST'S ADVICE

Drawing in restricted tones works particularly well in bright lighting conditions. Try to ignore local tones and concentrate on the fall of light and shadow. Think of cast shadows as essential elements of a composition.

CONTINUOUS LINE

Setting out to draw in continuous, flowing lines can help you to free up any tendencies to overly fussy and precise drawing. This technique often results in characterful drawings that would be difficult to produce by more measured means. The only rule is to resist the temptation to lift the pen or pencil from the page.

▶ Detailed bindings make a mummy an ideal subject for this approach, allowing the unbroken line to describe the form in overlapping contours. In contrast, the sleek curves of a classic car translate less well, but result in a drawing of quirky charm.

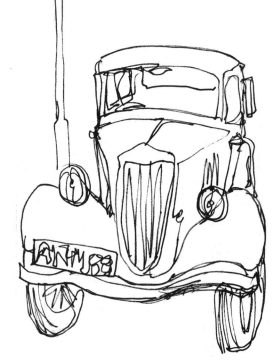

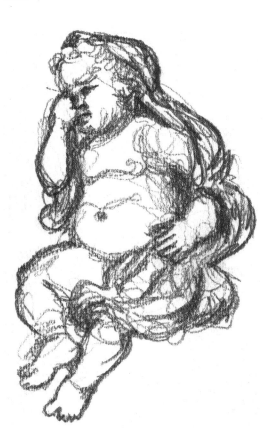

▶ The free-moving pencil can also be employed for degrees of tonal modelling when used in more vigorous actions. Even for drawings of heavy tone, the intention to keep the pencil on the paper stimulates a freedom and looseness of mark-making.

◄ To ensure a sound structure and composition, I loosely pencilled the main masses and perspective angles. Then I took a fine drawing pen and started working on a detail at the top left. I tried to avoid my tendency to backtrack, which meant moving from one element to another, often leaving the first incomplete. I only lifted the pen when it ran off the edge of the page.

▲ I continued in the same manner from other starting points and gradually the parts of the scene joined up. All the while I made meticulous observations of the individual items, trying to translate their characteristic shapes and materials in the rigid line of the pen.

◄ As the picture progressed I needed more and more starting points until I completed all the items and filled in all the gaps. I then used a broader pen to add definition to certain outlines. This is not within the strict rules of the exercise, but rules and restrictions are merely for guidance; ultimately it is the picture that matters.

BLUNT INSTRUMENTS

A really good way to keep your drawing loose and fresh is to work with tools that don't allow very much precision, forcing you to draw with broader sweeps and gestures and inventive mark-making. The results are often surprisingly effective.

► Here I used a short stick of black pastel turned onto its flat edge, which turned out to be ideal for the soft tones of the horse's coat and equally effective for the sharper outlines of the mane and tail. I am also pleased with how the straight edge of the pastel worked for the grass texture.

▲ With an old, splayed watercolour brush heavily loaded with diluted ink, I painted the crude outline form of a stuffed fish. I left some areas clear for highlights and also worked the ink more heavily around some of the details. The result has a looseness and textural feel that I wouldn't have achieved by working more meticulously. It was then quite easy to sharpen up the rough drawing with a fine brush and black ink.

► With the subject in shade and using a blunt crayon on heavily textured paper, there is little opportunity for precision. However, working the crayon repeatedly into the paper soon builds up definition around the features as well as quite subtle gradations of shade. It is a satisfying and unpressured way of working.

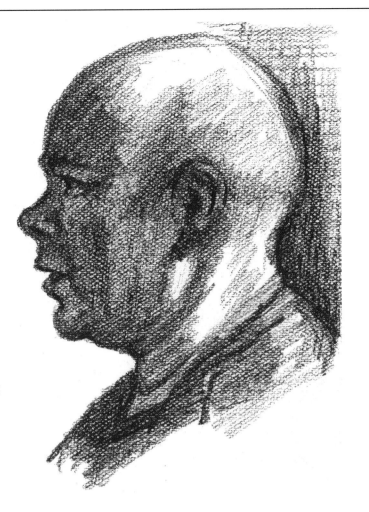

▼ Working with a broad bristle brush, my challenge was to convey something of the subtleties and finery of this Egyptian golden mask. I found myself putting on the ink in confident fat slabs and then scrubbing the semi-loaded brush into the paper for various mid-tones and markings. For delicate highlights I used white ink and merely touched the tip of the brush on the paper.

WORKING AT DIFFERENT SCALES

Another way of stepping outside your comfort zone and changing your habits is to work extra large or small. In doing so, you will find yourself holding your tools in a new manner and using different movements of the hand and arm that may unlock techniques you can then develop in your everyday drawing.

► I drew these dried insects life-size, using very fine pens and sharp pencils. Even with the aid of a magnifying glass it was difficult to observe the finer points, so it was necessary to make rough approximations of details and surfaces. Furthermore, every tiny movement of the hand had quite an effect on the drawing, so the marks had to be made with conviction.

Even in enlargement, such tiny drawings can look surprisingly convincing, free and unhampered by unnecessary fuss.

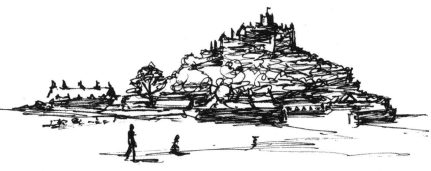

▲ The same approach can work well for subjects of any size. I drew these larger subjects at no more than 2.5 cm (1 in) across, so the scale limitation made it impossible to include every detail. Working in this way forces you to be selective in what forms to feature and any shading and textural marks you employ.

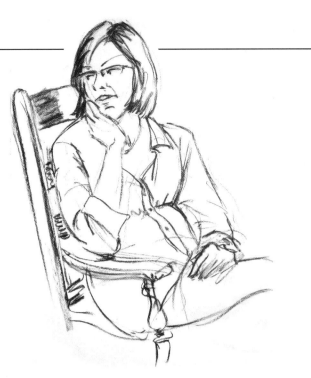

▶ At the other end of the scale, larger drawings demand that you stand at arm's length from the drawing board and use big motions from the elbow and shoulder. I did this portrait at A1 (84 × 60 cm/33 × 24 in), which allowed me to draw the model at life size. For the initial stage I drew very loosely with charcoal, just laying down the general pose and proportions.

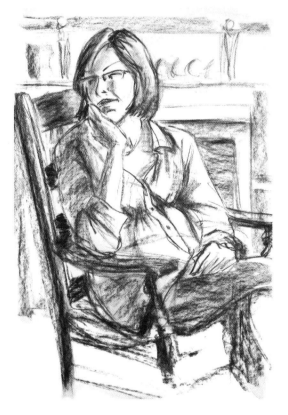

◀ Turning the charcoal on its side, I used broad sweeps to draw the main areas of tone and also to indicate some rough background detail.

▶ The scale of the drawing made it quick and easy to work the rough charcoal into a more finished portrait, smudging the tones with my fingertips and reworking details with more charcoal. For highlights and corrections, I used a large eraser in similarly swift strokes.

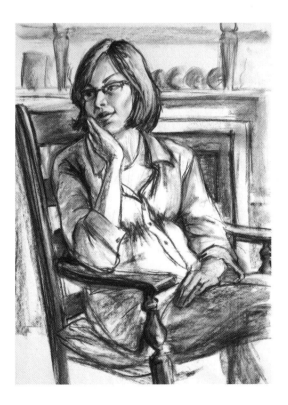

ARTIST'S ADVICE

When you are working at a large scale, try to fix your paper upright on a drawing board, door or wall. Working flat on the floor or table can mean you view your drawing at an angle, leading to distorted proportions.

TIME LIMITATIONS

Much of the artwork seen so far has been drawn quite quickly, albeit often with careful advanced thought and planning. This way it retains a boldness that can easily get lost if it has been worked too meticulously. Yet, despite the best of intentions, it's easy to get waylaid by details or too involved in a drawing to stop at the optimum point. To counter any such tendencies it's good practice to undertake some exercises with strict time limitations. You may be surprised at what you can produce under pressure.

▶ Here my desire to eat the breakfast overruled my tendency to fussy drawing. Working on a toned ground sped up the process too, as did the use of pastel pencils, which produce rich tones quickly.

82

▶ A model cannot be expected to hold a pose like this for very long at all. The time limit here was one minute, which may seem short, but it's quite enough time to establish the essence of the pose and figure. Such speedy work often translates into quite dynamic drawings (see also p.44).

▶ After some practice with one-minute drawings, you soon learn to pack a lot into three minutes. An energetic, sketchy approach helps, but the most important thing is to be accepting of unpolished results.

◄ Children are incapable of sitting still for any length of time. Taking a vigorous approach is always a good way to work quickly and decisively. Knowing that any early mistakes will soon be absorbed into the heavy, chaotic shading, you can proceed with confidence from the very start.

► In the tradition of oriental brush drawing, I spent quite some time looking at my source photograph and mentally rehearsing my brush movements before rapidly committing this cormorant to paper. The speed of execution and the associated textural marks are vital to the flavour of the drawing. Once it was dry I could add some selected details at leisure.

SKETCHING

Most of the pictures featured in this book have been done in sketchbooks on location. If you're serious about improving your drawing skills, it's essential to get out and about with a sketchbook as often as possible. Sketching takes many forms, often depending more on circumstances than artistic inspiration. Here are some tips on how to make the most of the circumstances you may find yourself faced with.

84

▶ Before photography, artists sketched to record information for use in finished artworks. In the same way, sketching can be thought of as a means of gaining familiarity with certain forms and subjects and practice at drawing them. Try some sketches that include as much detail as possible, however roughly drawn.

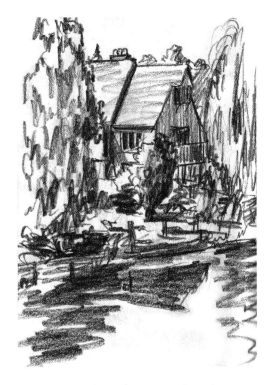

▲ Sketching objects from unfamiliar angles sharpens your drawing skills and increases your knowledge of the subject. You may also get interesting results.

▲ Appropriate mark-making can describe textures and lighting economically, bypassing a lot of time-consuming detail. Here the hanging foliage is rendered in simple, vertical strokes, while their reflections are conveyed in broad horizontal slabs of shade.

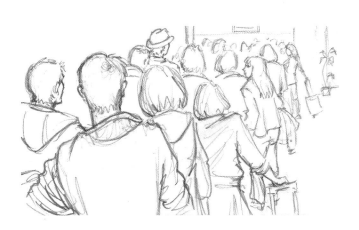

▲ Get into the habit of carrying a small sketchbook around with you. Even the busiest person can find time to sketch in the odd moments between activities. Wherever you are there will always be something worth drawing.

ARTIST'S ADVICE

Think of a sketchbook as a private diary. Use it to scribble down any odd details, compositions, rough doodles, ideas and experiments – whatever catches your eye or fires your imagination. Just a few strokes of the pencil can make a sufficient record of an idea that may otherwise become lost to you forever. The important thing is that you shouldn't feel inhibited by what anyone might think, because nobody else ever needs to see it.

▲ Drawing strangers helps to pass idle moments very pleasantly, but demands a degree of discretion. Hold your sketchbook out of sight, if possible, and try not to face your subject. Don't stare for long periods, but take quick, tactful glances. The more you practice, the less you will have to look at the subject to take in the information you need.

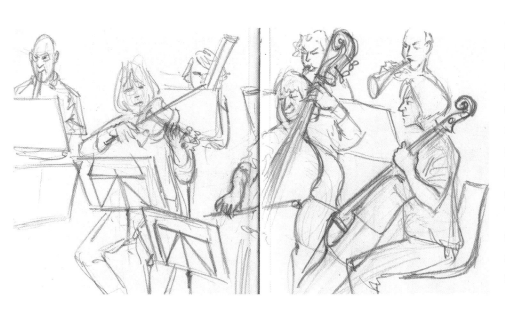

◄ It is only when you start drawing people that you realize quite how much they move about, even when performing repetitive actions. For groups of people it makes sense to keep the whole sketch on the go, flitting between the individual figures as they assume the appropriate positions. This simple-looking sketch took about 40 minutes, built up with an arm here and face there and a fair bit of waiting in between.

Sketching (continued)

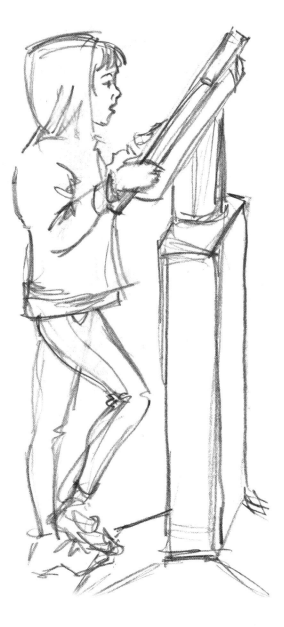

◄ Children and animals are notoriously difficult to sketch because they are constantly on the move. Trying to persuade them to stay still makes them fidget all the more and makes for stiff, unnatural poses. Catch them when they are absorbed in an activity and unaware of your presence – and draw them quickly.

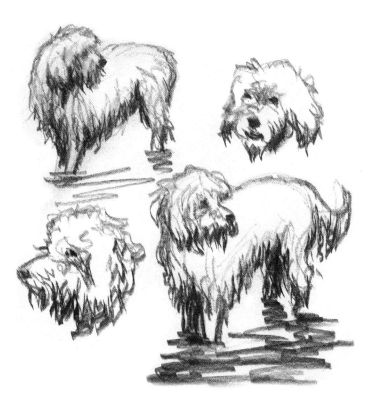

▲ Facing the challenge of uncooperative subjects soon sharpens up your skills of economy and invention. For this wading dog I held the pencil at a very flat angle and used the side of the lead to capture the tone and texture of the wet fur in swift up and down movements. The same grip with gentler sideways motions quickly approximated the fluffier upper surfaces of the animal.

ARTIST'S ADVICE

To draw moving subjects, work on several studies simultaneously, switching between them as the subject shifts pose. Work standing up so that you can easily shift your own position for the views you need. Be bold and make your marks count.

▶ Exhibits in museums and galleries, being inanimate, allow you as much time as you like, giving you practice at sketching complex poses or challenging angles of view. With a static subject you also have the time to work in different materials, but it's wise to limit your sketching tools to what you can comfortably carry in your pockets and handle standing up.

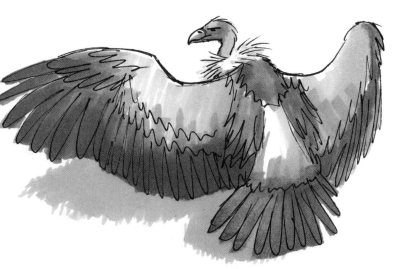

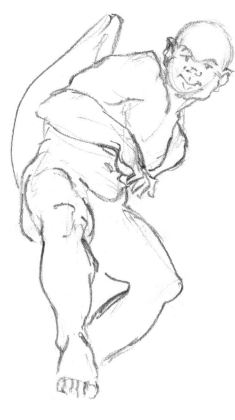

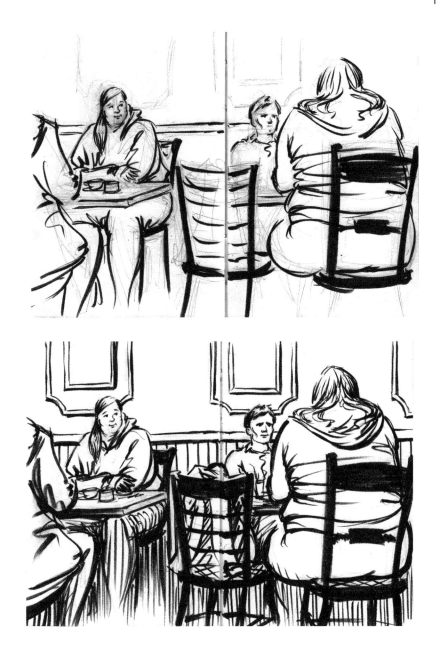

▲ Sketches that cannot be finished on the spot may be developed later. In a café, I jotted down all the important details across two pages of my pocket sketchbook, using a brush pen over rough pencil. Later on, working from memory, I developed the sketch into a more finished drawing.

SIMPLE FORM

Form has been discussed in some detail throughout this book so far, generally in terms of the practical description of objects. Here we shall revisit form as a concept worthy of self-contained artistic statements – where the focus is on the formal elements that say something about a particular subject or that seem interesting enough to make satisfying finished artworks.

◄ The gentle yet descriptive undulations along the frog's head and back, the way its body wraps around the stone, the voluptuous fleshiness of the limbs, the contrasting proportions, the delicate fingertips, the almost-human smile … All these and many more qualities make the pure form of this museum exhibit a subject satisfying enough without adding any complications of light and shade, texture, setting and so on.

▲ In this pocket-sized sketch the basic outlines of the cows are sufficient to describe the scene, but there's also something in the ambiguities between the individual creatures that helps to convey the eager crush of the feeding animals. Adding tone or texture might enrich or clarify the scene, but it would be likely to detract from the overall feeling.

▲ With subjects as charming as these old Malay puppets, a basic outline of their shapes and features is sufficient to do justice to their simply styled design.

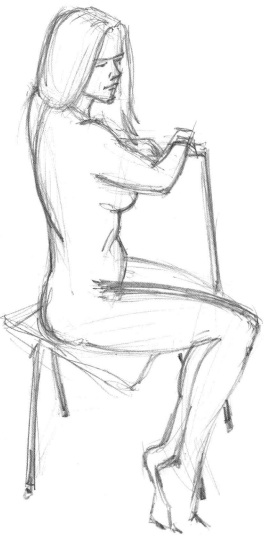

Here are various sketches of the same model, done on the same day. In each case my intention was to capture a different aspect of the model's physicality – angular, graceful, muscular – yet retain a general sense of the individual person.

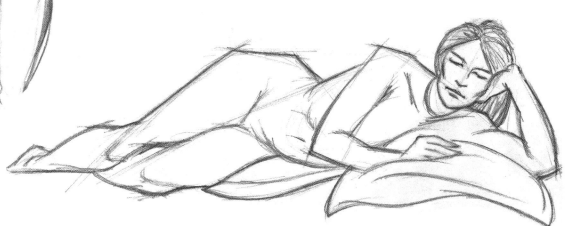

ELEGANCE

Beauty is very much a subjective concept, but there are many things that are generally agreed to conform to standards of prettiness, elegance or purity. It's not necessarily the case that such subjects will automatically make for elegant drawings; it may require a conscious effort to bring out the beauty in your drawing approach.

90

▶ I liked the graceful form and pose of the seated model on the previous page, but the roughness of the execution does somewhat spoil the elegance of the sketch. To make a cleaner version, rather than erasing the original and redrawing it, I made a tracing. To do this, I placed a clean sheet over the original and then put both sheets on a windowpane, which enabled me to see the original clearly enough to redraw the picture in a more graceful manner, using a soft pencil. I also replaced the unattractive chair with one that better suits the subject.

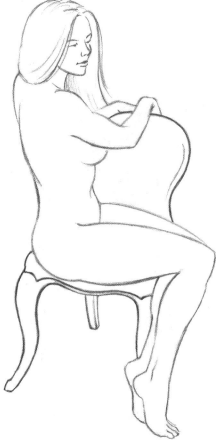

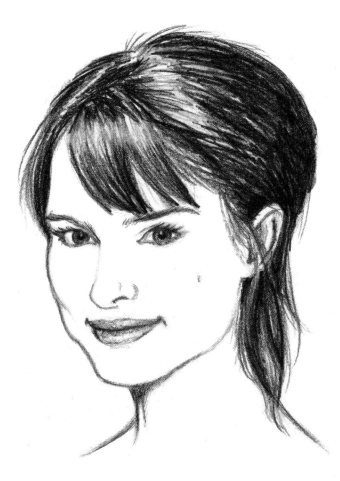

◀ Though the hair here is dense black in parts, I left the highlights quite pale for a sense of lustrous texture. In contrast, the face is barely modelled at all, leaving out any potentially distracting lines and hollows and relying instead on the distinguishing features, drawn in soft outline.

ARTIST'S ADVICE

It's generally easier to reinforce light pencil work than it is to clean up lines that are too heavy, so if you want a feeling of gentleness, start off light and firm up gradually.

► A medieval castle is not a subject one would naturally equate with elegance, but there's a fineness to the form and detailing of this example that can be brought out with a sympathetic line treatment. Again the omission of heavy shading and texture aid the effect, as do the simple point of view and composition.

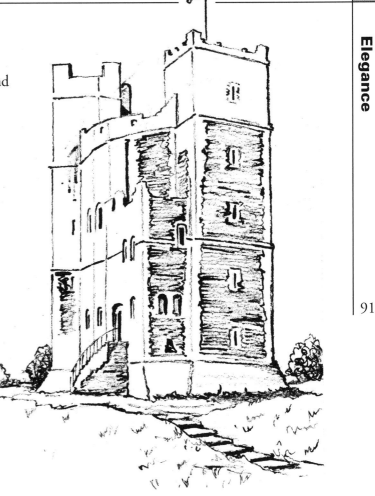

▲ Among the trees in a park, one stood out for me for its shape and stature. To bring this out in a sketch, I positioned myself for an uninterrupted view of the tree. Though the treatment is quite rough and textural, the shape of the tree snaking its way up the page makes for an elegant silhouette, especially in comparison with the more cluttered lower part of the drawing.

► The soft, waxy mark of a coloured pencil makes it easy to avoid the deep tones and harsh edges that would spoil the gentleness of a subject such as this. I kept the shading to a bare minimum, just enough to describe the roundedness of the face and the undulations of the fabric. The symmetrical view adds to the feeling of calm.

SYMMETRY

Although front-on views do not generally make for exciting or dynamic drawings, there are some subjects that lend themselves quite naturally to having their symmetrical aspects focused upon. The effects of such formal viewpoints can be quite varied, according to the subject and the artist's treatment of it.

▶ The heavy outlines and low viewpoint work together with the formal symmetry to make an imposing view of this library building.

◀ Although we may think of them as symmetrical, in reality most faces are rather lop-sided, so some tweaking may be required here and there to make a face conform to a symmetrical treatment. Here the fixed gaze of the model makes an impact and all surrounding details have been omitted to make the most of it.

▼ A distant and symmetrical view brings out the formal elegance of this Georgian mansion. Although the effect is almost diagrammatic, it is broken up by the off-centre, organic qualities of the mansion's surroundings.

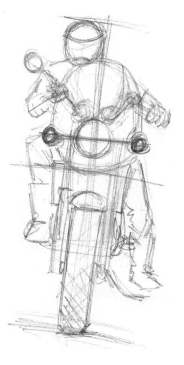

◄ Although symmetrical views can look quite precise and technical, they need not involve laborious drawing processes. Here I started with a very loose, rough under-drawing while a friend posed on his bike. I got the basic masses in place and then took a photograph to continue working from.

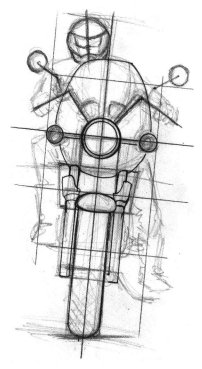

► At my desk, I ruled a rudimentary grid over the rough drawing, starting from a centre line. With the grid in place I could draw the main parts of the bike with pen and ruler and some circle templates for the lights.

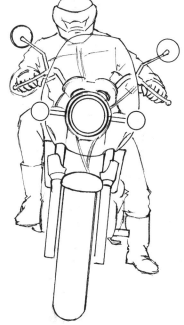

◄ After completing the general outlines I erased all the pencil marks. You'll notice that there are many mistakes, but most of these can be quite easily absorbed in the next stage.

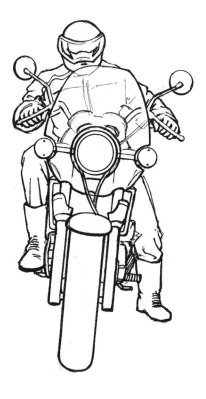

► With symmetrical views, any asymmetrical parts look immediately wrong, so work on details either side of the centre line, making any necessary adjustments to ensure both sides match.

When strengthening outlines you always have the option to work either side of the line, effectively allowing you to shift the line slightly and adjust slight divergences from symmetry.

GEOMETRY AND STRUCTURE

Beyond symmetry, subjects may possess many other kinds of formal and structural qualities that may be brought out as special features in your drawings of them.

► What attracted me to this cat on a cushion was the contrast between the roundedness and the angular. I started the sketch in pencil as a simple circle on a square and tailored the ballpoint pen outline to roughly follow the geometric shapes.

94

▼ The rigid grid-like structure that I brought to the fore in this sketch makes for an oppressive feel, pressing in on the figures from all sides, and enhanced again by the tight letterbox framing.

► Huge and bizarrely shaped bushes threaten to overwhelm a shed, crowding in from all sides. To accentuate the shed's plight, I focused on the solidity of the hedges, with heavy modelling to bring out the individual shapes and engulf the shed.

► The rigidity of the design is what interested me in this rocking horse, so I chose a formal side view and made the decision to draw it without any perspective. I drew all the main lines strictly vertical or horizontal and simplified the curves.

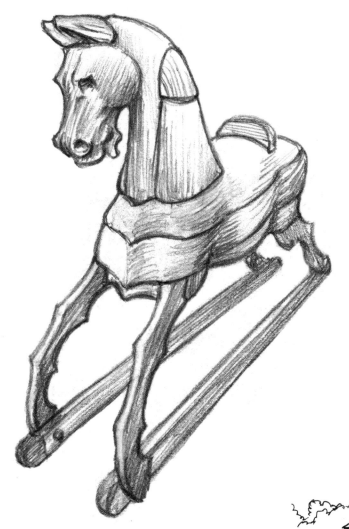

◄ I was interested in all the individual panels and blocks that make up this restoration project, stripped of its layers of paint and finish. In my drawing I exaggerated the divisions with heavier lines and also varied the shading direction to follow the wood grain of the separate blocks.

► Drawn from a distant, dispassionate viewpoint and devoid of detail, tone and atmosphere, this scene becomes a study of the triangles, uprights and horizontals that comprise the roofs of a farmhouse.

BRIGHT LIGHT

Without light there can be no vision and no drawing. In a sense, then, light is present for every drawing, but it takes a conscious decision to make a feature of it. Drawings can focus on many different types of lighting conditions, the most obvious of which is seen in the effect of great brightness.

96

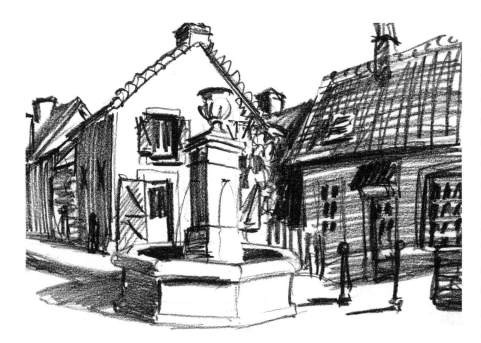

◄ Bright light tends to have the effect of increasing tonal contrast. Illuminated areas become very pale and shadows are very deep and dark. To sketch such conditions, ignore local tones and draw only the areas of shade, leaving lots of white for the palest areas. In reality, this scene had grey paving, sandy-coloured stonework and a deep blue sky, but shading them would greatly lessen the impact of the blazing sunlight.

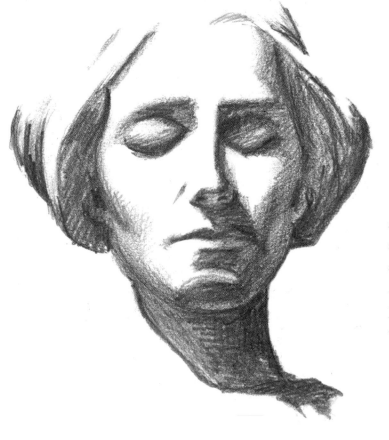

◄ Light alone may be enough to describe a subject. Here there is no outline, no texture, and very little nuance of tone between dark and light. The bleaching effects of light make it perfectly reasonable to allow the brightest parts to run off into pure white, an effect that is often quite pleasing to the viewer.

◄ Here the brightly lit front wall and columns are framed by areas of deep shadow in the foreground and background, making the illuminated centre of the picture stand out, almost glowing, in contrast.

▲ Without local tone, highlights are not usually visible. If you want a subject to look shiny it's therefore necessary to include more subtleties of tone or at least a strong mid-tone. Keep the overall contrasts high and the brightest highlights very clean and white.

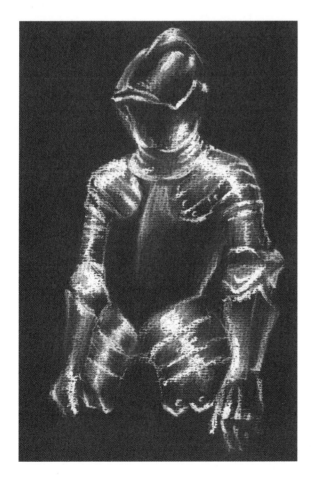

◄ On the other hand, you can draw with nothing but highlights. A toned ground stands as shade and local tone, and every white mark you make immediately appears to shine. Here I drew with a hard white pastel pencil, smudged for reflected light, and a very soft white pastel for the brightest highlights.

DRAMATIC LIGHT

**When you can take charge of light in your drawings you have
a very powerful tool for creating impact and atmosphere.
There's something about light to which we respond on an
instinctive level, so you have the viewer on your side already,
but it does require a tight control of tonal values to achieve
convincing luminous effects.**

98

▶ Even when the aim is to capture luminous
effects, the surroundings must be convincingly
drawn. I spent some time selecting the framing
of this staircase, establishing the general
perspective structure and drawing the main
shapes and angles.

▼ With a thick black marker pen I outlined the most
prominent features. Knowing that I would need the
full tonal range for this drawing, I used the black freely
to infill the areas of deepest shadow. I allowed a few
streaks of white to remain in the black areas to give a
naturalistic feel and because really solid black can rather
overpower a composition.

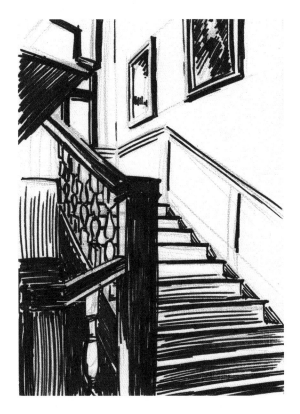

▶ I used a bristle
brush, semi-loaded
with diluted ink, to
paint in the general
areas of mid-tone
in broad sweeps,
making sure that
I left the paler
areas completely
untouched.

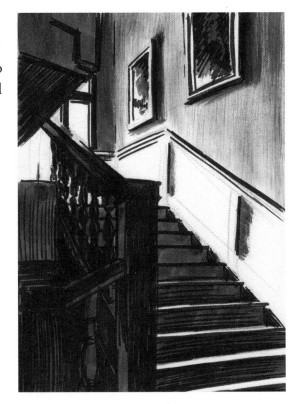

◀ For the next layer of tone I loaded the brush more fully and washed over the whole surface except for the very brightest areas of highlight, deepening the mid-tones, shaping the shafts of shadow and tying together the tones of the picture.

▶ For the final touches, I used a less dilute mix to dry-brush some selected areas of deep shade and then applied a few strokes of white ink for some detailed highlights where necessary.

Dramatic light *(continued)*

◄ The contrast between the brightly lit subject and dark sky is what gives this scene impact. As well as the striking tonal contrast, our familiarity with such weather conditions and the portent of oncoming storms creates a feeling of foreboding.

▶ Fire is always fascinating, but not always easy to draw. Work at the far ends of your medium's tonal range, keeping the bright areas clean and the darkness as black as possible. With a semi-abstract subject such as flame, it's a good idea to include some items or surroundings of definite and recognizable form to establish a sense of scale.

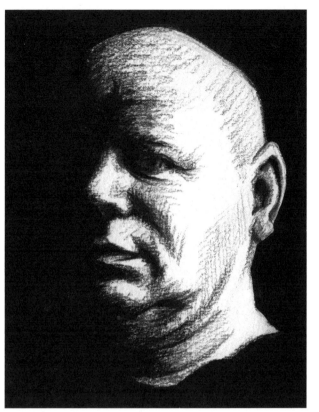

▲ Strong directional lighting can make for imposing portraits, creating deep shadows and modelling the features in stark relief. Taking things another step further, I added some ink to deepen the shadows and painted a background extending across the darkened face parts. Thus the head seems to emerge out of the darkness and, with most of the head now obscured, an air of mystery is created.

◄ The impact of light is all about managing tonal contrasts – the more darkness you employ, the brighter any highlights will appear in comparison. For example, the sky I observed for this sketch was in reality quite dull grey and the winter sunshine rather weak, but by exaggerating the darks the effect is heightened.

REAR LIGHTING

**An effective shortcut to dramatic lighting in your drawings is to select viewpoints that place your subject between you and the light source.
This rear-lighting reduces mid-tones to deep shade and silhouette and makes any highlights very crisp and bold.**

102

▶ Although this sketch is quite dark, it speaks of bright sunshine and summer haze. The shadows are as much a feature as the trees that cast them and silhouetted foreground foliage stands out boldly against the patches of sun-bleached ground. Distant details are pale and hazy in the exaggerated aerial perspective one encounters when looking towards the sun.

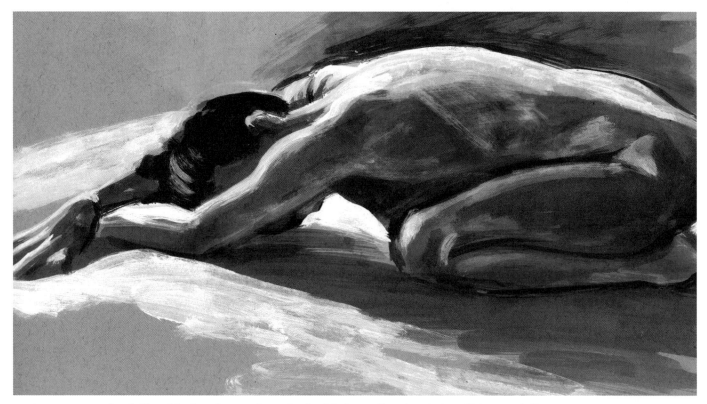

▲ Seen against the diffused light of a window, the highlights reflect brightly off the model's upper surfaces. To enhance the effect I painted dark ink around the top edge.

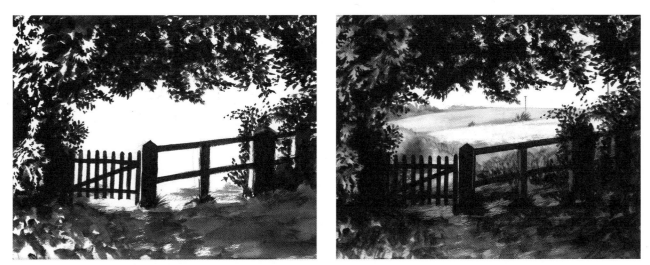

▲ Here the sun was behind me, but the illumination in the scene comes from the brightly lit landscape beyond the gate. With the foreground virtually silhouetted, I could paint all the detail with dark ink (slightly watered down for the ground surface). No pencil guidelines were required, but I went to some effort to make the appropriate marks for the various types of foliage. A few simple washes and details here and there completed what looks like quite a sophisticated scene.

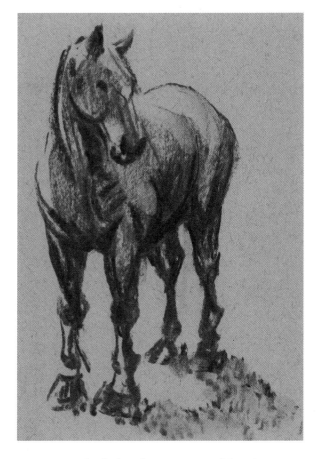

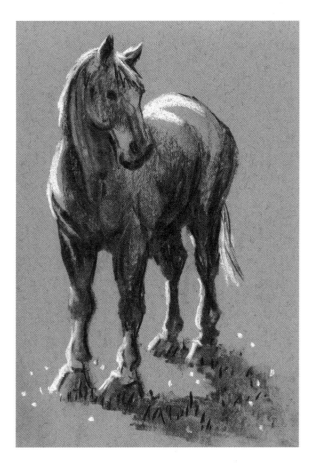

▲ Against the light, the amount of detail visible on this horse was quite minimal. I sketched it quickly with the broad side of short charcoal stick.

▲ Rear lighting produces halo-like effects that can be easily captured with a few strokes of bold white. The horse had moved by this stage, but the highlights were simple enough to reproduce without close reference to the subject.

ATMOSPHERE

Complex creatures that we are, we can have emotional responses to all sorts of atmospheric conditions. Boldness and light can certainly create a sense of drama, but we can be equally affected by their absence, in the romance of twilight, moonlight and even windswept desolation. Once again, the secret to creating such atmospheres is in controlling the tones.

104

► A sure-fire way to create a sombre atmosphere is to fill the frame with greys and to keep highlights to a minimum. Even though this small charcoal sketch features a broad tonal range, the feeling is still quite bleak due to the weak shadows and ominous sky.

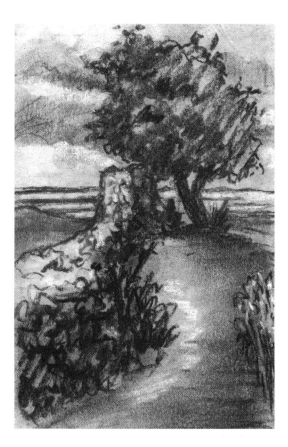

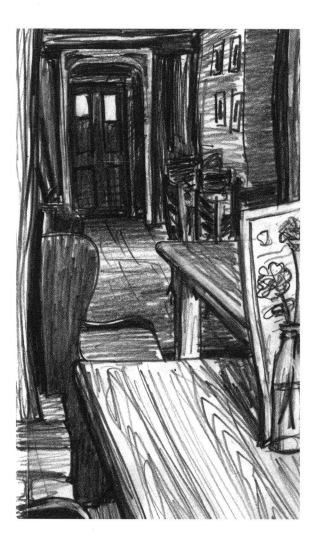

◄ Interior scenes such as this traditional pub also acquire an atmospheric feel when rendered in full tone.

▼ It does not take much to prompt the viewer to recognize certain atmospheric effects. This sketch consists of little more than a few slabs of black and grey felt-tip pen, but it manages to capture an authentic feel of late evening.

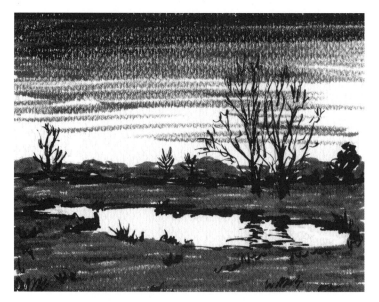

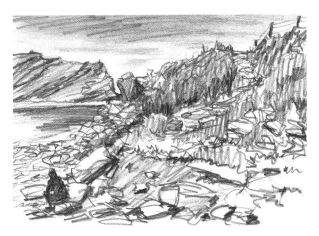

◀ Water-based materials lend themselves particularly well to scenes of bleakness. For this demonstration, I used a watersoluble pencil and scribbled in the main areas of tone and texture. In some ways I like the drawing as it is, but it could be more atmospheric yet.

▶ With a small bristle brush loaded with water – on this occasion, sea water – I worked in sections from the sky forward, dampening the pencil marks, blending them and pushing them around to fill the paper with rich tone, while striving not to obliterate too much of the textural feel.

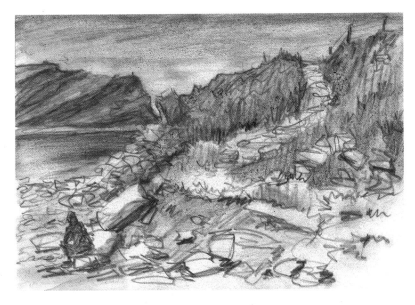

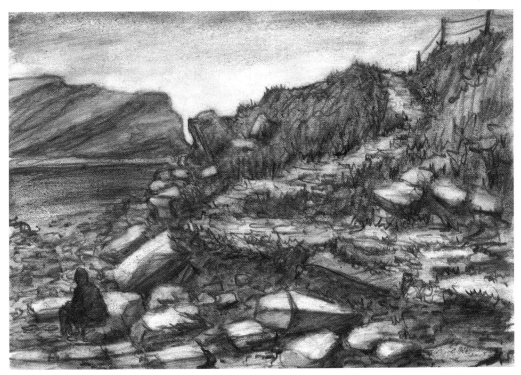

◀ Once the paper was dry I used the pencil again to re-establish the outlines and introduce more tone and detail into the foreground, before working over the drawing with the brush and water again. When it was thoroughly dry, I used an ink eraser to lift out some soft highlights on the rocks and lighten the sky for pictorial depth.

SPATIAL DEPTH

You have seen the effects of aerial perspective (see p.xx) and how useful it is to achieve an illusion of deep space in a drawing, and you have also learnt the benefits of reducing tonal variation for the opposite effect. With these skills in your repertoire you can approach some subjects purely in terms of their spatial depth and make it their main characteristic and the subject of the drawing.

106

▶ Standing under the spreading limbs of this ancient tree, I wanted to convey not only the background distance but also a sense of the huge limbs looming overhead and reaching out to the front of the picture. I used pure black ink in combination with grey pastels.

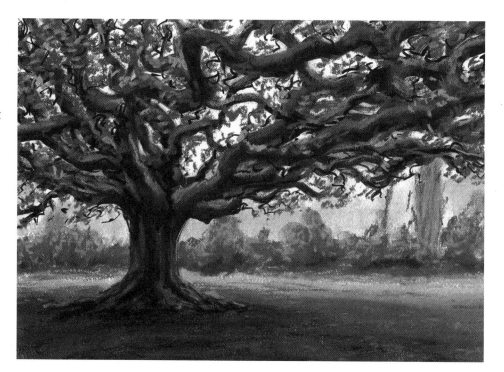

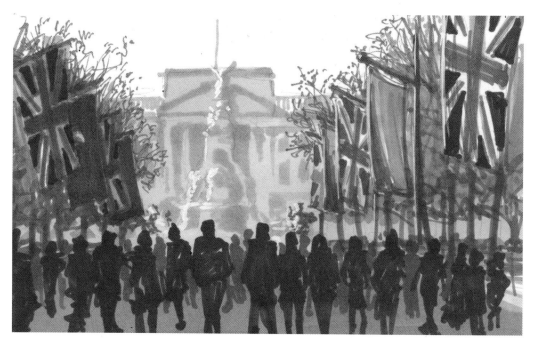

◀ Here I used four or five shades of grey marker to build up the scene from the far distance forward, getting darker in tone as I worked new layers on top of old.

◄ On holiday, I took some photographs of tiddlers some boys had caught in a clear plastic bucket. The murkiness of the water made the visibility extremely shallow, the effect of which was quite eerie. To replicate the effect it was necessary to work in layers. On some lightly textured paper I used the side of a charcoal stick to make swirly, random marks, denser towards the bottom of the page.

► I smudged and smeared the charcoal around with a fingertip, just enough to produce a cloudy effect, then added some more charcoal around the bottom edge. Using the tip of the charcoal, I rapidly drew some indistinct fish-like shapes and smudged them to varying degrees.

◄ Referring to my photographs, I drew some more distinct fish forms with charcoal, sharpened with a knife. To lift off highlights and errors, I made a 'tortillon'. This is a small piece of scrap paper rolled into a tight tube, the end of which is fine enough to lift, blend and refine small areas of charcoal or pastel.

► I then drew some fine strands of pondweed of various weight and tweaked some details and tones here and there. I sprayed it with fixative and, for a finishing touch, I used a viewfinder (see p.73) to select a suitably balanced composition before framing off the edges with a window mount.

SURFACE

An object's surface can inspire artists to consider such wide-ranging concepts as pattern, tone, shine and texture, and we have seen how each of these may be rendered on the page. Indeed, surface is so intrinsic to many subjects that it's hard to draw them without reference to it. Consequently, making surface a special feature of a drawing often requires very clear intentions and working methods.

◀ Here I concentrated on surface pattern alone, with no outline and almost no hint of shade – but in order to place the markings and features convincingly I first had to draw the ocelot in a conventional manner and then erase the outlines.

▶ There's barely a mark here that is not aimed at describing the feel of the turkey's wattles, its eye and beak being almost hidden within the texture. There's no need to minutely observe every bump and hollow of such a texture as long as you can convey its essential character in the kinds of marks you make.

▶ The rear lighting here reduced the scene to a kind of pattern, enhanced by the formal view and layered composition. Thus a subject of some depth is flattened, allowing the pure textural silhouettes to be the subject of the picture and the surface of the paper to become an important element in the reading of the drawing.

► In contrast, this peculiarly clipped tree form is all about textural depth. I used the stiff ends of a bristle brush to stipple the ink for the appropriate texture and kept the background details intentionally flat and featureless.

◄ Built of heavy blocks and tiles and surrounded by various plants and surfaces, this house obviously lent itself to a particular approach in the drawing. Even though the drawing bears all the elements of perspective, shade and so on, it still manages to come across as a textural study by dint of the busyness of every surface and the range of marks employed.

► Unlike the other examples here, this sketch of a mirrored surface (the lid of a waiting-room bin) provides no texture of its own. Being curved, however, it makes its presence felt in the distorted perspective of its reflection.

Surface *(continued)*

For heavily and variously textured subjects it can be tricky to keep the distinctions between the elements clear and the drawing readable. To achieve this in a drawing of a densely foliated garden, I worked in layers and also varied the materials to make the depth of the composition clear.

▶ After making rough pencil guidelines I drew in the cottage with a very fine-tipped drawing pen (0.1 mm), working mostly in horizontal and vertical strokes and trying to avoid making it too detailed and fussy.

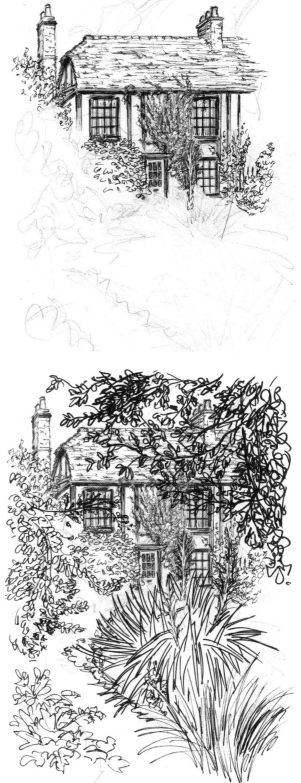

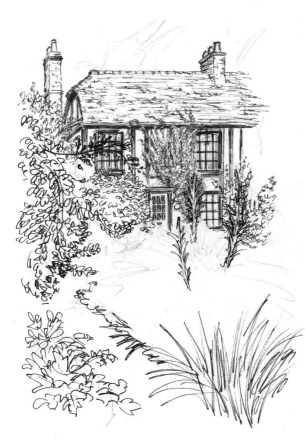

▶ Working towards the foreground, I used successively broader pens in appropriately larger marks, giving each different plant its own kind of mark. Don't be afraid to draw over the top of previous layers; the overlapping is a great device for enforcing spatial depth.

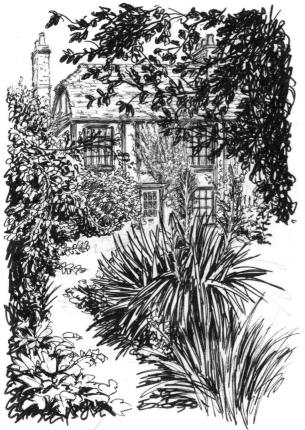

◄ Next, to really push the depth and bring out the individual forms, I used some heavy black shading, again working in marks that were sympathetic to the plants they aimed to depict.

► I filled in the gaps with the appropriate pens, being careful not to overwork them. It's important to allow some space for the eye to move through the scene and when the scene is as busy as this, such little moments of relative calm are especially welcome. To finish I erased all the pencil marks and framed off the edges. The tight framing with details running off every edge helps to make scene look really full to overflowing.

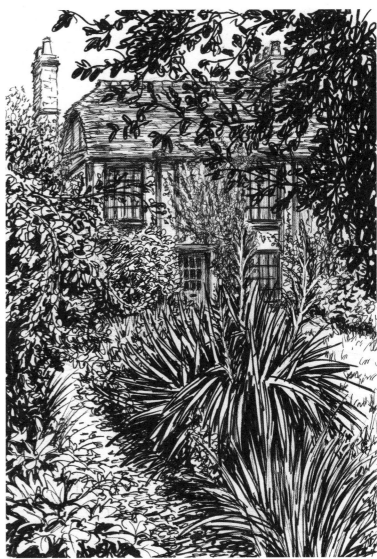

REAL LIFE

In our lives we tend to favour tidiness and cleanliness, yet those virtues in drawing can come across as stiff and sterile. Evidence of wear and dirt lends drawings a sense of truth and honesty about a subject, making the artist appear more competent and sophisticated. It also shows something of life going on in the real world, which is far more visually appealing than a pristine, lifeless environment.

▼ These are two sketches of the same pig, a noble beast but hardly a delicate specimen. In one I aimed to emphasize the coarse hair and inelegant attitude, while in the other I concentrated on the mud staining its legs and snout. Both are scruffy sketches that say something about the animal's nature.

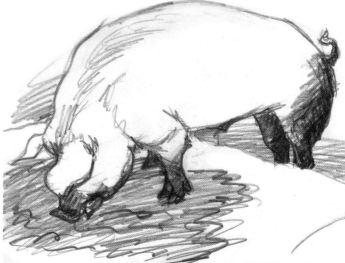

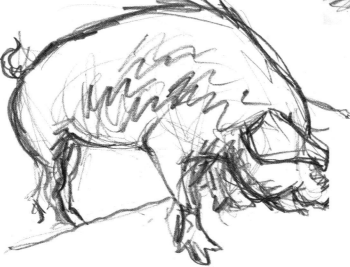

▶ The drawing language you use goes a long way towards defining the level of scruffiness you want to achieve. Here's my wife, not looking her best admittedly, her unkempt work clothes and general dishevelment accentuated by broken outlines, random shading and smudges.

► Once you accept dirty or untidy subjects as valid, there's a whole new world of subjects open to you and you need not look far for inspiration. This sketch has been smudged and stained by its opposite page in a sketchbook, but the extra scruffy marks only add to the effect.

◄ With its capacity for line, shading, brushmarks and wash, watersoluble pencil can be used for effortlessly scruffy effect. The more slap-dash the fashion in which you use it, the more effective the results. I added the graffiti over the top with a white chinagraph pencil.

> **ARTIST'S ADVICE**
>
> Using a harder pencil or drawing lightly for underdrawings and guidelines makes the marks easier to erase. Here, I have drawn quite heavily with a soft pencil for the sake of clarity.

▲ Ramshackle levels and weed-infested, broken surfaces gave this old garden gate a feel of clutter and disarray. I used the pen in a semi-continuous line manner (see pp.xx–x) and applied a couple of watercolour washes in imprecise motions that strayed beyond outlines.

A COMPLEX SCENE

As we have seen, working quickly and freely brings the necessary feel to subjects that aren't clean and tidy. It also helps to give liveliness and freshness to the drawings. More complex scenes featuring multiple elements require a more carefully considered drawing approach, but if broken into logical steps even very cluttered scenes may be drawn very broadly without sacrificing readability.

► I used a broad, soft brush and quite a rich solution of ink. Having selected a suitable framing with a viewfinder, I started with the main subject, the deer, drawing only the broad masses of deep tone in broad slabs.

114

◄ With a thinner mix, I worked on all the mid-tones. Although it looks quite random, I was looking out for any masses of highlight, for which I needed to leave the paper untouched.

► To bring some form to the blocks of tone I switched to a finer brush and undiluted ink and worked on the outlines of the main elements. It became apparent where I had gone astray with my original tone drawing, but I let the outline generally follow the placements and forms of the tone drawing.

▶ Even though the drawing up to this point may not have been entirely accurate, once the main forms were established the rest of the details could be drawn in to fit within the spaces available. It may be tempting to fill in with random shapes and marks when you do this, but it's always worth taking your cues from observation of the scene.

◀ I reverted to the diluted ink to strengthen some of the tones and to work around some of the infill details, helping to give them form and definition. Then I used white ink for highlights, quickly dabbing and stroking in the same carefree manner as the rest of the drawing.

WEAR AND TEAR

There is something appealing about things that are old and falling apart. A new fence would rarely be considered for anything more than its practical function, but an ancient, tumbledown, overgrown wall fills our hearts with joy. But even when a subject is falling apart it should be clear in the drawing that it is damaged, not just badly built, or, even worse, badly drawn!

▲ With the wobbly lines and rough marks of a battered old brush, my aim here was to convey a feeling of everything sagging and tired. Even so, the sketch was drawn over quite careful perspective guidelines.

▲ The ink does all the work here, but a touch of tone in watercolour adds richness to the subject and a bit of grime. Some white ink provided highlights, but only to restate some drawing features, such as the window bars; I certainly didn't want to make anything look shiny.

◄ This subject requires a degree of structure to the drawing. In the first stage, I counted, measured, and evenly spaced the planks and panels of the shed's construction, almost as if drawing a new shed.

► The first things I inked were the parts that overlapped others, such as the hinges, foliage and bucket. Then I loosely sketched in the structural forms and characterful details, occasionally exaggerating wonky angles.

◄ With a touch of ink I filled in the deep hollows to give the subject depth and form. I was careful to avoid making the black too neat and uniform, allowing the brush to run dry in parts. I then erased my pencil lines.

► In proceeding to add some textural marks I was cautious about overworking and muddying the picture. It was important to vary the degree of weathering on the surfaces and to leave some parts relatively clean.

Wear and tear *(continued)*

► Old and distressed subjects need not be drawn in a rough-and-ready style to look appropriately aged. Despite its obviously crumbled and overgrown state, this arch remains stable and dignified, which I tried to show with sturdy perspective and a clean rendering manner. Strong light and shadow also reinforce its solidity.

118

◄ Some subjects speak quite eloquently for themselves and demand no special emphasis or treatment. With the ancient axe's warped, split shaft and broken, pitted head, a straightforward drawing of outline and texture is quite sufficient to convey its great age.

► Signs of age may be more subtle. To draw the wear and tear on these girl's shoes I selected a formal overhead view, from which the sag of the material is observable as well as the acquired lack of symmetry between the pair. Some stretch marks and a bit of fraying also help with the effect.

◄ People too get more interesting (and easier) to draw as they grow older and their faces become more careworn and characterful. I started this old fellow with a suitably vigorous under-drawing that marked the main crags, wrinkles and high points. I also looked carefully at the sagging lower jaw and neck, which add greatly to a convincing portrayal of age.

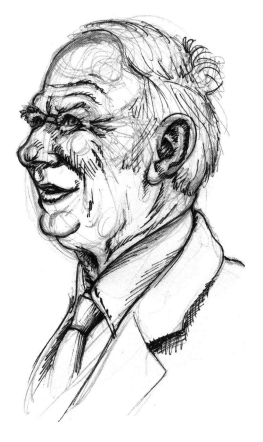

► I chose an unforgiving black pen for the drawing and worked first on the features of age and character in heavy lines and hatching.

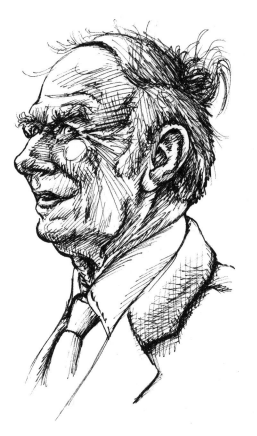

◄ Next I worked up a semi-tonal rendering in swift, jagged motions that follow the directions of wrinkles. I also spent some time on the hair and particularly the rather unruly eyebrows. Tempting though it was to continue shading ever more detail, there comes a point where extra marks add nothing new and actually start to detract from a drawing.

PERSONALITY

With such diversity and subtlety of subject matter in the human face and form, it's no surprise that artists are drawn to the idiosyncracies to be found there. The challenge is always the same – to capture the particular essence of an individual. That essence can usually be contained in a few strokes of a pencil – and no amount of detailed rendering will make up for a failed likeness.

120

▲ A great way to get to the heart of an individual personality is to practise exaggerating the most noticable features of the face and amplifying the expressions. Caricature is a tricky skill to master, but it shouldn't be painstaking. Here are a few of the dozens of quick caricatures I sketched over an hour or two in an art museum, spending no more than two or three minutes on each. In your own sketches, look at face shape, notable features, expressions and attitudes and allow yourself to distort proportions quite freely.

▲ After some practice at caricaturing, you should find that you develop a feel for the individual characteristics of a face. I drew these examples immediately after the previous caricatures, seeking this time to merely respond to the subjects rather than impose my will upon them. The results are mildly caricatured but quite accurate likenesses, yet without the effort of careful observation and measuring.

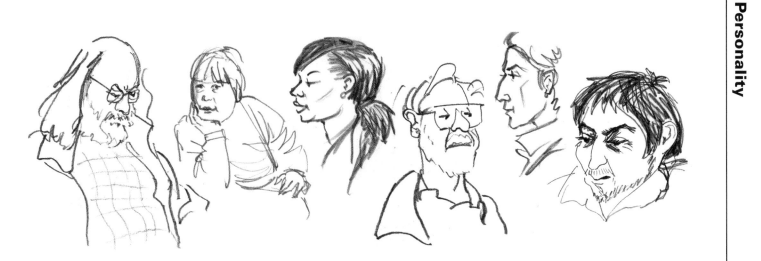

▲ This is a tiny selection from the many quick character sketches I have done over the years in waiting rooms, cafés and buses. When people are unaware that they are being observed you see them at their most natural, often quite bedraggled or melancholy. Draw swiftly with the aim of capturing the personality behind the blank expressions.

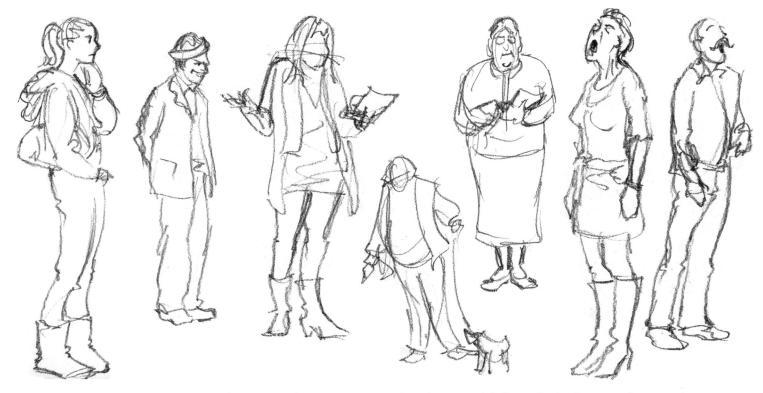

▲ There is much more to personality than people's faces. Body shapes and proportions, clothing, hairstyles, age, posture, gesture, and many other factors contribute to the mix of an individual character. Drawing family and friends is great for getting started but to really sharpen your skills, get out among the public and sketch all sorts of people as boldly as you can. It is by repetition that you will quickly gain familiarity with all sorts of body types and the telling subtleties of body language.

NARRATIVE

As soon as you place two or more figures in an environment, you stimulate the viewer's curiosity. We humans have an in-built desire to know what's going on between characters and to seek a satisfactory reading of an image, and it's remarkably easy to set up simple interactions that play to this fascination. And so we move into the realm of telling stories with our drawings, giving them a life beyond the marks on the paper.

► The narrative in this sketch of train passengers is suggested by the body language, the woman leaning forward with an edgy expresson, the man more laid-back and uninvolved. Odd little moments like this are playing out all around us all the time – all it takes is for the artist to set them down on paper.

122

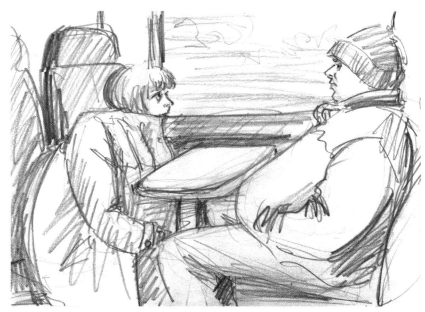

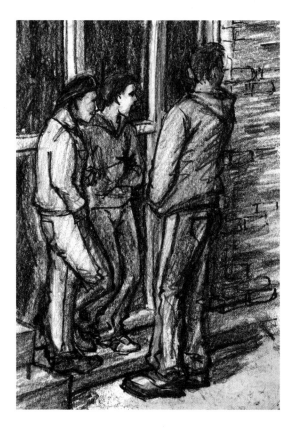

◄ A group of youths huddling on a street corner is a subject likely to stir a response in many viewers and all the more so if the drawings capture the gloom and grime of the setting. However, what intrigues here is the unseen focus of attention beyond the frame of the picture.

► I livened up a boring lecture by sketching the speaker against his old master backdrop and introducing a knife into the mix. That the two elements are of similar scale and drawn in a similar manner creates a potential for interaction. In drawing you can have endless amusement by combining elements in creative juxtaposition, changing the meaning or perception of each.

123

▲ The very fact that there's no obvious interaction between the inhabitants of this bar poses some questions of its own. A scene like this sets up expectations but the drawing is vague enough to provide few answers, compelling the viewer to make assumptions about the time of day, the mood, the relationship between the figures, their backgrounds and so on.

▲ There are no figures to create a narrative in this scene, yet the disturbed furniture tells its own story and it's hard to avoid a sinister reading. And then, in the mirror, is that a person reflected? And if so, what is their involvement?

PART III: *Interpretation*

To be able to draw is very rewarding, for there are few thrills to match those almost magical moments when some quick strokes of the pencil produce a convincing depiction of three-dimensional reality. At such times, all the early struggles and failures that you have to go through to reach that point become worthwhile.

Once you have mastered the basic skills it may be tempting to continue drawing traditional subjects such as flowers and teapots, each time replicating the thrill of getting it right – but there is no reason why aspiring artists should not aim a little higher and strive to make their drawings more impressive. This does not necessarily mean more complicated – indeed, the opposite may very well be true – but a little thought can go a long way towards turning run-of-the-mill academic studies into artistic statements of impact and intrigue.

So, in the first half of this book, we shall look at the devices you can employ to bring the best out of your drawings of the world around you. To start with we shall examine the benefits of carefully selected viewpoints to add interest to your compositions, then we shall investigate the various materials and techniques that will further enhance your range of expression.

You should soon find that your drawing skills develop into whole new realms of possibility, but this is only the beginning. We shall move on to more and more inventive approaches that will encourage you to manipulate your subjects in all manner of ways, gradually leaving behind any tendencies you may once have had to render the world like a mere camera does. The aim is to bring out the artist in you, and an artist bends the world to his or her will.

For sharpening your skills and developing your eye, there is no substitute for drawing directly from a real-life subject. Ordinarily I would not advocate drawing from photographs, but because of the imaginative nature of this book some of the subjects and techniques depend on them. Ultimately, all that matters is the finished image, and the route is unimportant. However, if you want to become a fully rounded artist, I recommend that you draw from life wherever possible.

SUBJECT MATTER

Do you remember, when you were a child, wanting to make a picture but being unable to decide what to draw? Perhaps you are still plagued by the same frustration. However, the solution is so often to be found right in front of you. In learning to see and think like an artist, you will discover that fascinating subjects reveal themselves at every turn.

126

It could be said that there is no subject unworthy of your attention; an artist will find something interesting in the most mundane of surroundings. That may well be true, and I hope that this book will point you in precisely that direction, but you can also give yourself a head start by seeking subjects that are interesting of themselves. You can practise drawing a conventional subject such as flowers in a vase, or hone the same skills by drawing weeds thrusting out of cracks in a wall. I know which picture I would more enjoy looking at.

▲ Essentially this is nothing more than a typical academic drawing exercise, but because these flowers are wilted and dying, it avoids the usual prettiness of the subject and subverts the cliché. It can be a lot of fun playing with artistic conventions.

◀ Often the most interesting aspects of a scene are to be found by looking above the everyday life of street level.

▶ With a subject as immediately striking as this mummified cat you can hardly go wrong. There is nothing stylish about this sketch (done in a museum), but the subject matter makes the viewer want to know more.

▲ Look out for spontaneous moments and be prepared to act quickly. This blackbird made a habit of perching atop a garden ornament. She never hung around for very long, but I was waiting for her with sketchbook in hand.

▶ There is much mileage to be had from irreverent, humorous or even vulgar subjects.

◀ A subject of innocence and beauty will always be a joy for the artist and the viewer.

128

VIEWPOINT

Part of the role of an artist is to examine different ways of looking at a subject rather than just accepting the obvious. The viewpoints – the angles and positions from which you choose to depict your subjects – make all the difference to the success of your drawings.

▲▼ FRONT VIEW

Human portraits drawn directly from the front usually look little more interesting than a passport photograph, however stylishly drawn or rendered, but the same viewpoint presents this sheep with a degree of symmetry that is rarely seen in these nervy, skittish creatures. This view also accentuates the mass of the fleece compared to the skinny legs and small head.

▲ PROFILE

The side view of these gravestones shows them to be leaning at odd angles, which would be less visible from other viewpoints.

▼ REAR THREE-QUARTERS VIEW

This angle gives us an unusual 'behind-the-scenes' glimpse of a seaside amusement. A view from directly behind would be confusing, but the three-quarter angle makes the scene readable.

► In another rear three-quarters view, the structure of this fairground sign is more noticeable than the wording, which would dominate the picture if it were legible. This is also a good angle to portray the birds' forms as it breaks up the symmetry of the front view.

► REAR VIEW

This sketch demonstrates a concept that will frequently be alluded to in this book: 'less is more'. This viewpoint offers very little detail, but still conveys much about the character in a view that is not often depicted.

LOOKING DOWN

Further possibilities arise when you consider the height from which you view your subjects. It can make a huge difference to the impact of a drawing if you make the effort to look down on your subjects from above.

◄ This is an illustration I did for an educational book. With its level viewpoint, it objectively describes the animal's features and proportions – but it can hardly be considered an artistic statement.

130

◄ In contrast, this drawing, though technically less polished, is much more interesting. The viewing platform at the zoo gave me a view that is unusual and therefore immediately eye-catching. Because the head is closer to the viewpoint, it occupies a larger area of the picture and shows more of the animal's character.

▲ For this student study I balanced a mirror across the backs of two chairs and crouched underneath, giving a view of myself from above. It is good practice for an artist to study the familiar from unfamiliar viewpoints.

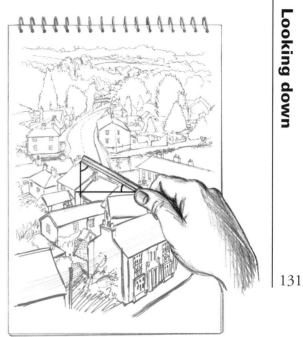

▲ There are many angles in a drawing like this, but they need not be too confusing to draw. All vertical lines should be drawn strictly vertically, while other angles can be assessed with the aid of your pencil. Hold it vertically about 30 cm (12 in) in front of you, then tilt it left or right until it lines up with the object you want to draw. Holding that angle, move the pencil down to the relevant area of your page and draw t he line.

▲ The view from the top of a church tower allowed me to see parts of my town that are invisible from street level and opened up the scene into an interesting composition.

ARTIST'S ADVICE
A viewpoint looking down on a person usually has the effect of diminishing their presence, making them seem weak and subservient. This device is often employed in narrative illustration and comic books.

LOOKING UP

Drawing from low viewpoints may require you to crane your neck, crouch down or even lie flat on the floor to find the ideal angle for a particular piece. But you must sometimes suffer for your art, and the results will often make the struggles worth while! Low viewpoints can be especially effective for bringing interest and presence to ordinary subjects.

▶ I drew this giraffe in a museum while sitting on the floor. Notice how distant the head looks and how solid the body is compared with the example on page xx.

▲ Placing the mirror on the floor allowed me to make this rough painting as if looking up at myself. Not only is the low angle of view arresting, but it also has the effect of conveying an attitude of superiority or haughtiness.

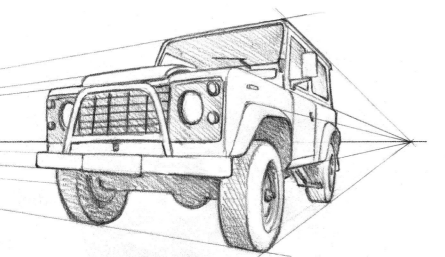

◀ The same principle applies to inanimate objects; it is not an unconscious decision that leads advertisers to depict vehicles from low viewpoints, as is often done.

Drawings such as this can be tricky to get to grips with, but a little basic perspective can help. As this diagram shows, along the eye level (or horizon) the lines remain horizontal, but all horizontal lines above and below the eye line drop away at increasingly sharp angles. All these lines converge at points on the horizon. Thus, a grid of guidelines may be drawn quite easily to assist with making such a drawing convincing.

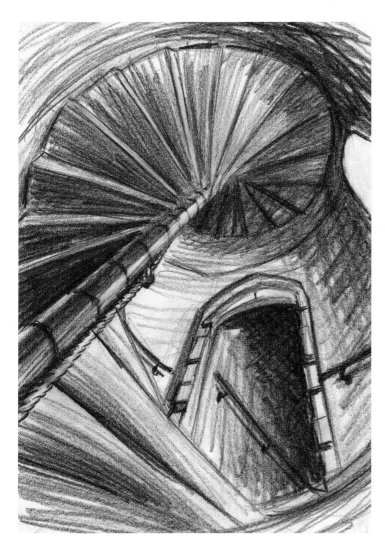

▲ To sketch this ancient staircase, I chose to look directly up to show the undersides of the steps as they spiral out of view.

ARTIST'S ADVICE

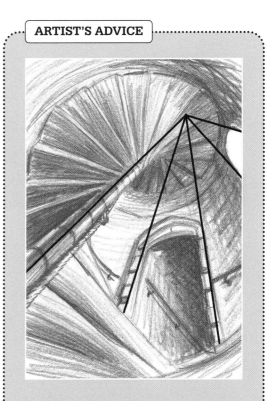

Looking up at such sharp angles can present you with some confusing angles to draw, but again some simple perspective guidelines an help. The angle causes the vertical lines to converge at a single point overhead.

VIEWPOINTS NEAR AND FAR

Just as important as the angle and level of viewpoint in affecting the impact of a drawing is the artist's proximity to the subject. To demonstrate how great an effect this can have, consider these three views of the church and statue in a town square.

134

► From a distance, the scale of the statue is seen in its relative proportion to the church behind it and acts as a mere detail against the expanse of the church. This is a dispassionate and objective viewpoint.

◄ From a much closer viewpoint, the statue becomes more of a feature of the drawing. The distance between the two subjects is also more apparent and we feel more of a sense of involvement in the scene.

► From a stance near the base of the statue, the church is further diminished in relative scale and importance, appearing little more than a decorative backdrop to the dominant foreground feature.

► A very close viewpoint is useful for emphasizing selected parts of a subject. For this giant lobster museum exhibit, I positioned myself very close to those fiendish claws so that they seem even larger than life and really dominate the drawing.

ARTIST'S ADVICE

SIGHT SIZING

With the apparent distortions of scale that come about with close viewpoints, it can be tricky to judge relative sizes accurately. To help with this, your pencil can be used as a makeshift ruler. Holding it out in front of you, measure a particular dimension of your subject and mark the length with your thumb. It should be easy to find other parts of the subject that have the same measurement from your point of view. You can then check that the relevant proportions match on your drawings and adjust as necessary. For example, from my viewpoint, the breadth of the foreground claw here is equal to the length of the creature's main head and body section and the pincer part of the other claw.

BREADTH OF VIEW

When considering the many viewpoint options for a drawing, we must also think about the possibilities presented by different breadths of view. From a microscopic detail to a vast panorama and every stage in between, how much of a scene you choose to depict has an effect on what your drawing says about a subject and how much impact it has.

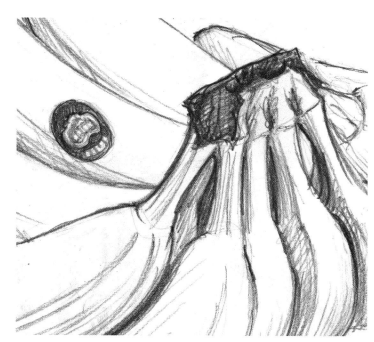

ARTIST'S ADVICE

A homemade cardboard frame makes an excellent viewfinder that is very useful for helping you to choose suitable framings for your drawings.

▲ Selecting a small area of a subject brings a fresh dimension to what may otherwise be quite a boring drawing. Such framings can produce almost abstract compositions.

▶ If you broaden your field of view, new subjects become available to you. The central focal point of this sketch is essentially empty and all the interesting bits are around the edges.

◀ By looking down into a water butt I caught this unusual view of the reflections in the water. The view is focused on a small patch of space, concentrating the eye and eliminating peripheral detail.

◀ This panoramic drawing takes in nearly 360° of the scene in one flat image, more than the eye can normally see in a single view without turning the head from side to side. It required several days' work over three large sheets of paper. Note how the perspective has been distorted to accommodate the unnatural field of vision.

MAKING ARRANGEMENTS

As an artist, you are under no obligation to draw things exactly as you find them; your task is not to document reality so much as to make interesting images. We have seen how your choice of viewpoint can influence your take on a subject, but you can push this a step further by enforcing your will upon the subject and altering how it is arranged for artistic effect.

138

▲ This is a set of Russian dolls, just as I found them on the shelf. It is a pretty boring picture in every sense, but it need not have been. Even a subject as formless and unexpressive as this can be rearranged in almost limitless ways for the sake of impact, quirkiness or fun. You may need to give items extra assistance, such as propping them up, sticking them together with tape or manually holding them in position, but there is no need to show those practicalities in your drawings. Also, you can bring in extra elements or simply add them from memory. Remember: in art, anything goes.

◄ With a subject as richly articulated as the human body, the possibilities are greater still. In posing his model for this bust, the sculptor has brought great tension into the pose through the twist and tilt of the neck and shoulders. From any angle this pose would make for a dynamic sketch.

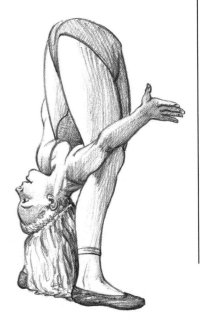

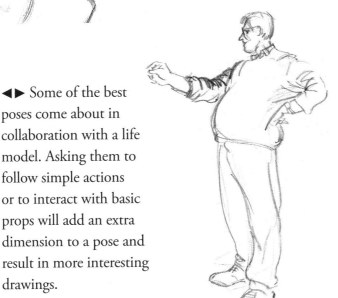

◄► Some of the best poses come about in collaboration with a life model. Asking them to follow simple actions or to interact with basic props will add an extra dimension to a pose and result in more interesting drawings.

▲ The human body is capable of bending into the most amazing shapes. Extreme contortions, like that of this street performer, are impossible to hold for any length of time, so it may be necessary to work from photographs.

◄ It is equally valid to pose models merely for the shapes their bodies can make. Strong, flowing curves, sharp angles, physical tension and so on are all effective elements in a pose.

> **ARTIST'S ADVICE**
>
> When arranging difficult poses, be prepared to work quickly to avoid inflicting discomfort on the model. Time pressure can benefit your work as the model's tension creeps into your drawing with often quite dynamic results.

DRAWING LANGUAGE

Thus far we have concentrated on what to draw, selecting subjects and viewpoints from the world around us. The next thing to consider is how to treat the chosen subjects, which brings us to the slightly obscure realm of 'drawing language', or 'style'.

◄ Attempting to render a drawing with photographic objectivity will usually cause you a lot of hard work for little effect. Here I carefully recorded every modulation of light on every wrinkle, but it is a boring drawing, little more than an academic exercise.

Every artist quickly develops a unique manner of drawing, just as everyone has recognizable handwriting. For example, most of the images in this book should be generally identifiable as being by my hand. Although it would be folly to try to change the way we draw once we have found our style, each new drawing still presents us with infinite possibilities. Our choices of materials, technique, scale and so on will very much affect the outcome. More important still is what we choose to convey.

When you pare down a subject to an essential function, you are likely to make a drawing statement that has impact. Always try to be clear and unswerving about what you aim to achieve with every drawing.

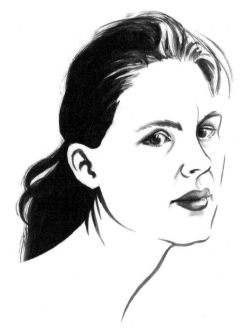

▲ Here is a simpler, more considered treatment. Ignoring most of the light and form on the woman's face and concentrating on her basic features achieves a fresh, elegant feel, instantly more eye-grabbing than the over-worked drawing above.

◄ This head is rendered in two different drawing languages. The basic portrait is sketched in loose pencil marks, but for the girl's tiger stripes I used a brush and watercolour. This mimics the way the make-up was applied and makes a clear distinction between the natural and the artificial.

ARTIST'S ADVICE

SIMPLIFICATION

If there is one golden rule that can guide us towards making successful drawings, it is that old but true cliché 'less is more'. It cannot be stressed too strongly or too frequently. Good artwork is more about what you decide to leave out than what you include. Any fool can make things complicated; it takes a thoughtful artist to keep things simple.

▲ Here I have deliberately restricted the drawing language to bare, uniform pencil lines. The aim is to convey a sense of confusion in the jumble of lines and shapes. A more sophisticated treatment would clarify the divisions between the objects and spoil the effect.

PENCIL LINE

To start our investigation of simple drawing language, let us pare things down to basic line drawing. While an outline drawing may appear to be the easiest approach, it is not without its difficulties. With pure line, you do not have any extraneous marks to hide behind; every stroke of the pencil stands to be judged, not just for the form the line describes, but for the weight and quality of the line. However, there are ways to ease the strain.

142

▶ It takes great confidence to put down outlines in a quick sketch like this without prior underdrawing, but that is what makes such drawings effective. Every mark that you make could potentially spoil the drawing, so keep it as minimal as possible. Accept from the start that it may take many attempts before you achieve one success. A blunt pencil is very forgiving compared to the precision of a fine point.

▲ By choosing a subject that is scruffy and unkempt you are not faced with the same pressure to keep the lines graceful and precise. However, it is still effective to make your marks fluid and confident.

▲ The fine point of a mechanical pencil, combined with angular, stabbing marks, lends this ancient skeleton an appropriately hard-edged feel. Note that the lines are heavier for the foreground bones and less distinct towards the back. This helps to create a sense of depth.

◄ It is often necessary to do a drawing twice over to get it right. Many great artists do rough versions before embarking on a masterpiece. Here I have made a carefully observed sketch, but as you can see it is riddled with guidelines and errant marks.

◄ However carefully I attempt to clean up the drawing, it remains quite rough and unrefined. The answer is to do it again, but this time with my first drawing as a guide.

► By tracing the initial drawing onto clean paper, each mark can be made with complete confidence. For this final version, I used a very soft, broad pencil and thought carefully about the weight and breadth of each mark, making them darker in areas of shadow and fading out to nothing on the upper edges. The varied line helps to describe the subject's gentle contours.

ARTIST'S ADVICE

For the final drawing I used layout paper, which is thin enough to see through to a drawing placed underneath. To trace through onto normal drawing papers, artists work on a lightbox, effectively a translucent drawing surface with a lamp behind it. Alternatively, you could affix your papers to a windowpane and make use of the daylight coming through the window.

INK LINE

**In neat ink, all lines and marks are uniformly black.
This dense black lends itself to bold graphic impact
and, as it is stable when dry, any number of scruffy
pencil guidelines can be erased with ease.**

▶ Here is a rough sketch I made of a craftsman
restoring an old wall. It is not very polished, but
it will provide a good basis for an ink drawing.

144

◀ With a flexible metal-nibbed
pen, dipped into black ink, I
carefully drew the outlines and
developed the facial features –
with experience of drawing comes
the confidence to make up odd
details without reference material.
For the bricklayer's plumbline, I
used a ruler to echo the precision
of its purpose.

▶ When the ink was thoroughly dry I could erase all
the pencil marks, leaving the clean ink line. Then I
strengthened some of the outlines to give a sense of
weight and solidity to the figure and bricks.

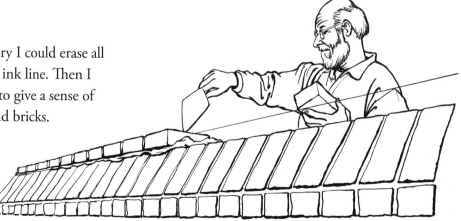

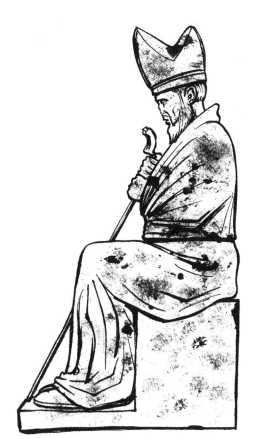

▶ Here I used brushpen – a felt-tip with a brush-shaped nib, which produces bold marks of varied breadth. I also shaded the very darkest areas of the clothing with solid black, which lends the figure a sense of solidity.

◀ I accidentally splattered ink on this drawing and dabbed the messy ink blobs with a tissue – but I was pleased with the resulting textural look of rough stone so I repeated the effect over the body, shaking the pen and dabbing with a tissue. Once it was dry, I used white ink to cover the marks that had strayed beyond the outlines.

◀ The even line of an ordinary felt-tip pen lends itself to a stripped-down approach. Here there are no fancy techniques or effects to hide behind and it took me many failed attempts along the way. It is often advisable to work over light pencil guidelines..

ARTIST'S ADVICE

Artists' dip pens take a little practice to get used to, especially in the way the nib responds to pressure to produce lines of varying thickness. Practise doodling on scrap paper to gain a feel for the tool. Always use downwards or sideways strokes to avoid the nib splattering. Be sure to rinse the nib in water when you have finished.

▲ There is a fresh and unfussy quality to this ink and brush sketch that can only be achieved by drawing very quickly and confidently. I worked from a photograph, using a Chinese calligraphy brush and cheap fountain-pen ink.

INK AND TEXTURE

Still using nothing more than pure black and pure white, it is possible to bring greater sophistication to your designs by introducing texture. It is not difficult to convey texture in a black line drawing, but you must be careful that you make the appropriate kinds of marks for the surface you hope to describe.

146

▶ Here I used an artists' felt-tip drawing pen to establish the outlines over a fairly rough pencil drawing. I made the lines appropriately jagged or smooth where necessary. The texture of the outline is very important to the way a drawing reads when finished.

◀ With the same pen I then made some scaly marks over the body, observing the sizes of the scales, tiny around the eye, larger on the back. It is not necessary to draw every scale; a few well-placed examples suggest the overall surface. Here I concentrated on texturing the 'mid-tones', the areas where light and dark meet across the body's surface. I also marked some detail on the leaves, using unbroken curved lines in contrast to the lizard's texture.

◄ Some drawing ink and a fine brush filled in the areas of deepest shadow. In reality, the light and shade on the chameleon was much more subtle than this, but simplifying the lighting has an exaggerating effect and makes a strong feature of the texture, which is what this picture is all about.

147

► After erasing all the pencil guidelines I added more scales here and there to blend the transitions from dark to light. I also made some outlining bolder and used white ink to correct errors and pick out some scales against the black. The texture in this picture has the effect of making the body seem rounded and three-dimensional, the scales working like shades of grey in between the black and the white areas.

▲ This drawing is based on a photograph of a chicken taken from a steep angle. I liked the formal symmetry of the body and the framing of the head within it. I started with a simple underdrawing, where I was careful to note the direction of the feathers in the plumage. Then, using a fine watercolour brush (no. 3) and black drawing ink, I carefully outlined the main shape and the features of the head.

▲ With a larger brush, I filled in areas of solid black, using the appropriate textural marks in the transition from the paler chest to the very dark back.

▲ Switching to white drawing ink, I drew detail into the solid black area and added some highlights to give form to the feet. I also used the white ink to break up the outline around the breast to give the bird a more delicate, feathery feel.

TONE

Tone refers to the shades of grey between the extremes of pure white and pure black. It may take the form of delicate pencil shading, ink hatching, flat slabs of grey paint, smudged chalks or charcoal and so on. In a drawing, tone can perform many functions: it may describe light and shade, surface texture, three-dimensional form and local tone, and it may also serve the formal qualities of picture-making.

149

▲ The strong lighting for this pencil sketch naturally bleached out the brightest parts of the face to pure white. In the second version, I further reduced the shadow areas to broad masses of black and grey poster paint. Though crudely applied, the effect is immediately more striking.

◄ The two shades of grey in this drawing depict only the 'local tones' – the inherent tonal values of an object. Without the effects of light and shade, images may be confusing to the eye, but careful design (like the mat here outlining the feet) can provide the necessary clues.

◄ For this charcoal drawing, I contrived a minimal shading scheme to bring out the softness and roundedness of the subject. It is not a realistic portrayal of the lighting conditions and, other than the hair, there is no local tone present. My aim was to avoid adding any unnecessary marks.

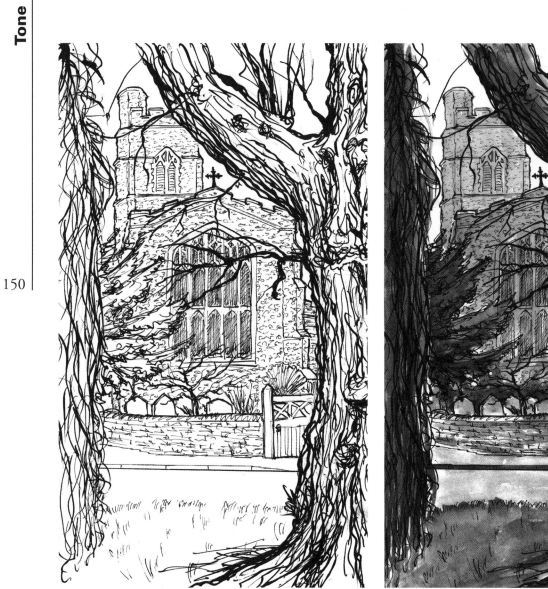

▲ Despite the use of a range of marks, the ink line drawing here struggles to be clearly readable.

▲ With the addition of some very rough washes of tone, the layers of depth in the scene are easily discernible.

ARTIST'S ADVICE

Applying washes of diluted ink or watercolour is a quick and easy way to introduce tone to your drawings. Use a soft, well-loaded brush and make sure that the drawing is done in pencil or ink that is not water-soluble. It is also important to work on paper that is heavy enough to resist buckling with moisture.

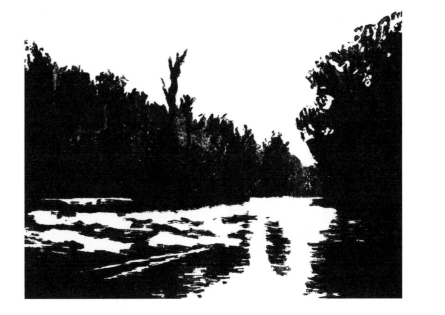

These three prints came from the same blocks, inked up for two, three and four tones. You can see what a difference the number of separate tones makes in the clarity of the scene, the level of detail and also in the mood or atmosphere of each finished print.

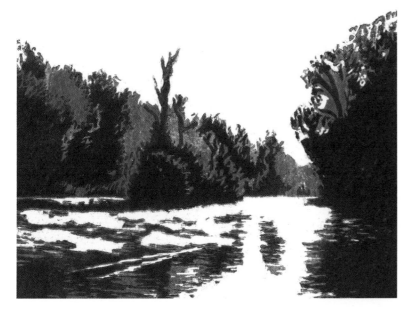

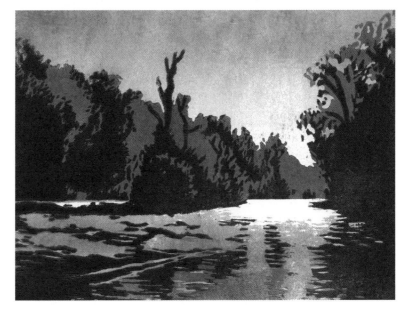

TONED PAPER

A great way of getting used to drawing with simplified and controlled tones is to work on grey or coloured papers, known as 'toned grounds'. The benefit is that the mid-tone is already established, so all you need to worry about are the very dark and the very light areas. Bear in mind that a strong image will result from leaving a lot of the paper's tone untouched.

▲ This picture is based on a photograph I took from a small boat. The low viewpoint gave me an imposing view of the ship and distant land mass and also a close up view of the sea's surface, which suggested this framing of the scene. Very rough pencil guidelines established the basic shapes and set a scale for the ripples of the sea.

▲ A 5 mm artists' felt-tip pen (with permanent ink) was a good tool with which to add some detail to the background. The fine line and sparse detailing keeps the objects looking distant.

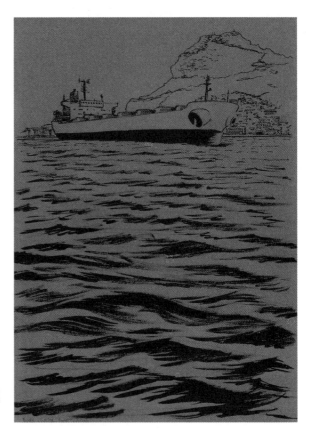

▶ Using a medium-sized round watercolour brush, I filled in the solid black of the ship and worked on the sea. Rather than trying to slavishly copy the actual waves from my source photograph, I simply aimed to capture something of the characteristic texture of gently rolling water. The important thing is to make the marks bigger and bolder in the foreground and diminish evenly towards the horizon.

▶ With the tone of the sea established, the background was looking weak, so I used the pen to add more tone and texture.

◀ Here you can see the great benefit of toned grounds; with just a few accents in white ink, the whole picture springs to life and the highlights really stand out strongly. It is easy to get carried away at this stage, so remember to let the grey of the paper remain wherever possible.

TONE AND TEXTURE

The further you delve into the world of tonal drawing, the more important are the marks you make to describe different textures and surfaces. Even tools as basic as pencil and charcoal are capable of a great range of textural expression, which you should exploit to bring clarity and feeling to your work.

154

▲ Though the picture is quite gruesome, this is still a beautiful creature and I strove to capture that in smooth, unbroken strokes of the pencil. Different areas of plumage required different kinds of pencil marks, as did the harder surfaces of the entangling vines.

▲ I sketched this quick self-portrait during a spell of ill-advised beardedness. The vigorous textural marks make up most of the drawing here, with just a little outline detail to give context to the textural shapes.

▶ For an interesting take on these old shoes, I strung them up on an old wooden door. I went for a deliberately loose treatment and allowed the point of the charcoal to roam around the outlines and wrinkles of the leather. A few vertical strokes are sufficient to suggest the grain of the door, in contrast to the busier marks of the shoes. I kept the chalk highlighting to a minimum, so as to avoid anything looking too shiny and new.

► Here I used a short stump of charcoal laid on its side to make some very simple, broad strokes of tone. I then added selective spots of detail with a black brush pen.
I was careful to keep the detail minimal and allow the initial freeform charcoal marks to do most of the work.

◄ To sketch this bronze statue I took no particular care over the marks I made, being more concerned initially with drawing the form and capturing the light and shade. I worked on grey paper with chalk and charcoal, filling in the background afterwards in white ink.

► Because chalk and charcoal are so unstable it is possible to blend the tones of a drawing with the tip of a finger. Here I kept all my smudging strokes in a uniform diagonal direction. Where I restated some details in charcoal or chalk, I made all new marks in the same direction.

EXPERIMENTING WITH TEXTURE

Every different tool and material has its particular strengths and individual characteristics. As you become accustomed to using them, you will quickly gain an instinct for which methods are most appropriate for particular effects. Mixing materials and techniques can produce very effective, individual and often unexpected outcomes.

▲ This hen-pecked ex-battery chicken was one of the ugliest creatures I have ever seen. I wanted to capture its extreme scruffiness, as well as the attitude it displayed strutting around my aunt's farmyard. To get into the right frame of mind, I chose to work on the cheapest, flimsiest paper I could find. I then scribbled the main masses and just enough bare detail to guide me for the ink at the next stage.

▲ With a fine brush and neat black writing ink, I outlined the main details of the head and feet. This would provide the drawing with some recognizable elements which would allow me to be less restrained with the rest of the body. For the ruffled feathers, I switched to a very old and battered watercolour brush that splayed out to form several points. This automatically provided the appropriate feel for the feathers.

> **ARTIST'S ADVICE**
>
> Don't throw away your old worn-out brushes; they can be used for all sorts of painting and drawing effects that would otherwise be difficult to achieve.

◄ Artists normally try to avoid getting dirty fingerprints on their artwork, but here I dabbed on neat ink directly with my fingertips, aiming for a sense of carelessness. I then diluted the ink and used a coarse bristle brush to wash it across most of the hen's body. Then, for extra scruffy effect, I dipped an old toothbrush in the ink bottle and splattered the drawing with dust-like speckles.

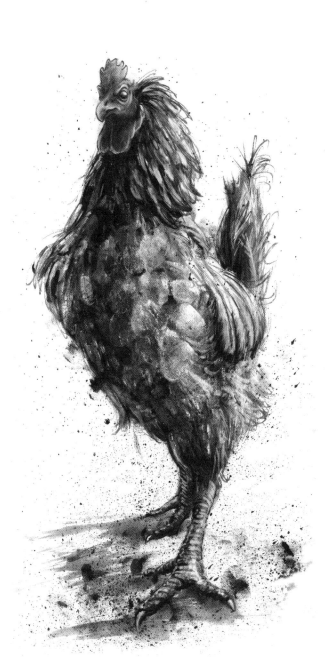

► Once the ink and wash was dry, I applied more fingerprints, this time in white drawing ink, which brought out the roundedness of the body as well as providing the textural feel I was after. Using the same ink with a brush, I added a few accents and highlights here and there to reassert the drawing and vary the texture of the different kinds of feathers.

ILLUMINATION

Much of the past few pages has involved a sense of light and shade; we can hardly think about tone without it. However, there is more to be gained when we concentrate on illumination as an essential part of a drawing. Lighting is one of the artist's most powerful tools for conveying atmosphere, drama and dynamic impact, just as it is in the medium of cinema.

◄ Here is a rough sketch I did after a wrist operation. It is crudely drawn, but the lighting gives it some impact. In this image we see the two main effects of bright lighting: the shade along the inside of the arm and hand, and the shadow cast on the surface below.

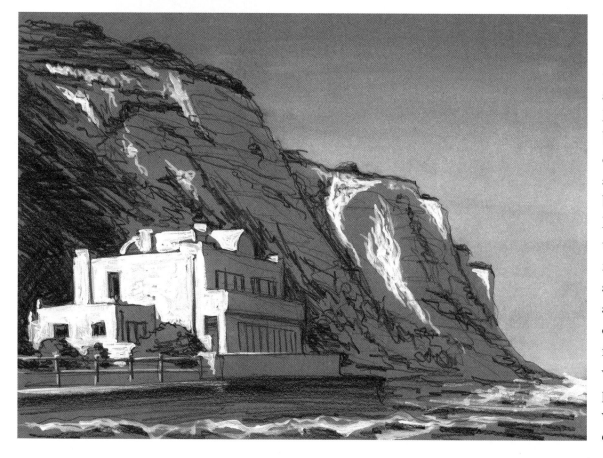

◄ The bright side-lighting here makes the building stand out sharply against the background, but light does more than aid our reading of this scene; it forms an important compositional focus without which the picture's impact would be greatly diminished.

► The depth and quality of shade immediately implies the strength of light, however simple the image. For this swift study I used a few deft strokes of diluted ink to state the shading. The same grey tone gives the outlining of the back a brighter feel compared to the pure black ink of the darker detailing.

▲ Lighting need not be dramatic to be effective. Here I intentionally subdued the lighting by reducing any tonal contrasts to shades of grey. The result is a bleak atmosphere that would be less effective with bright highlights and deep shadows.

► Looking into the direction of light rewards us with bright reflections and silhouetted details, resulting in an immediate sense of drama.

DRAWING WITH LIGHT

We have seen how adding bright highlights to a drawing can give it an instant lift and breath of life. We can also make drawings that are composed almost entirely of highlights. Working on a black surface with a white drawing tool produces an effect known as *chiaroscuro* and makes for dramatic images. It takes a little thought, though, because drawing with light is the very reverse of the conventional drawing process.

160

▶ Scraperboard is composed of a chalky layer covered with a dense black surface. A scraping tool cuts through the top layer to reveal the pure white beneath. This medium is ideal for drawings of great tonal contrast and also lends itself to very finely detailed work. Working from a photograph of a characterful medieval wood carving, I drew the rough outlines onto the scraperboard using a soft white pencil.

▲ With vertical strokes, following the grain of the weathered wood, I scratched away the outlines and broad masses of light on the illuminated left-hand side of the image.

◄ I then inscribed the fainter secondary light on the right-hand side. However bright and direct the light source, there is nearly always a degree of reflected light which bounces off surrounding surfaces and affects the subject.

► Turning my attention back to the main lighting, I reworked the areas of brightest highlight to model the roundedness of the surfaces. For areas of extra brightness, I slightly varied the direction of scraping. A few spots of black ink corrected a few minor errors and I wiped away the remaining pencil guidelines with a damp cloth.

◄ For this chalk drawing I set up a skull on a dark background and illuminated it with a single candle, placed at a low angle to create an eerie effect.

I started by blocking in the masses of light with a stub of white chalk turned on its side. After smudging and blending the chalk with a finger, I used the end of the chalk to gradually refine the shapes and bring out the brighter highlights. I then corrected some stray marks with a soft eraser.

DRAWING WITH AN ERASER

Of course, erasers are essential for correcting errors, erasing guidelines and cleaning up spots and smudges. However, when the contrast of light and shade is a feature of a drawing, the eraser takes on another important use in picking out highlights and adjusting tones.

┌─────────────────┐
│ **ARTIST'S ADVICE** │
└─────────────────┘

Do not be afraid to go through a messy stage in the course of your drawings. It often happens that the act of retrieving the drawing generates that extra ingredient that makes a picture interesting in the end.

162

◄ I posed the model outdoors and had her look directly into the diffused daylight overhead. It was a hard pose to maintain, so I very quickly sketched the basic shapes with a fairly soft pencil and then took a photograph to continue working from.

▶ With a soft pencil, (4B) I roughly shaded the main areas of tone. For the effect I had in mind for this picture, I did most of the shading in a strictly vertical direction and covered the whole surface with graphite.

▲ I used a hard plastic eraser to crudely lift out the main areas of light, again working in a vertical direction and allowing the eraser to smudge and pull the tone around.

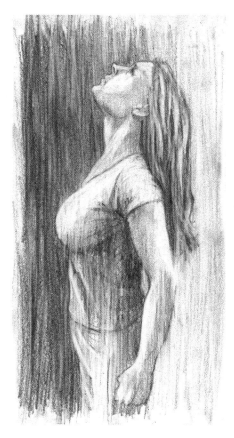

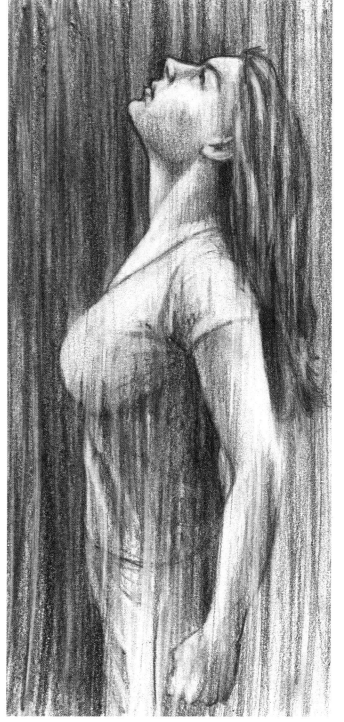

▲ I sharpened the corner of a soft rubber eraser with a knife and used it to carefully lift out some more delicate highlights and generally draw the form back into the areas of light. I wiped the eraser clean after each stroke to keep the highlights clean and bright.

ARTIST'S ADVICE

Heavily applied graphite can very easily be smudged with the heel of your hand. To avoid this, lay a clean piece of paper between your hand and your drawing. It is also good practice to wash your hands regularly.

▲ For this final stage, I used a pencil style of eraser, sharpened to a fine point, to hone the delicate highlighting around the head. Then I reverted to the pencil to redraft details of the face and hair. I also used pencil and eraser to subtly adjust tones and textures all over the drawing.

COMPOSITION

Throughout this book the artworks have tended increasingly to have definite edges, or 'framing'. This is a natural result of incorporating tone into the work, but it is also a very important subject in itself. Before progressing any further we should start to think of framing and the placement of the elements within it as an essential consideration for any drawing.

Composition is all about the balance and dynamics within a picture. It is a vast and fascinating subject. It will crop up repeatedly throughout the book, but for now a few examples will serve as a good introduction.

► CURVES

Running through this complicated scene is a bold and simple curve that leads the eye into the picture. Such a compositional device should be the first thing you draw; if the curve looks balanced and graceful, the picture will be all the stronger for it.

◄ THE GOLDEN SECTION

Since ancient times, artists and architects have followed a mathematical 'golden' ratio that dictates the most pleasing division of a space – about six tenths. So the horizontal division in this composition comes six tenths down the picture and the focal point (the figure) is placed at six tenths along that line. The golden section is a great shortcut to instantly gratifying compositions.

◀ A FRAME WITHIN A FRAME

Many compositions are based around bold geometric shapes. They are often not immediately visible, but they may also be very much a feature of a picture. One such device presents a subject through or within a frame-like structure within the picture. The effect may draw the eye into the picture and may echo the staging within a theatre's proscenium arch; it may also feel voyeuristic.

165

> **ARTIST'S ADVICE**
>
> Make quick compositional sketches before you start a drawing, since they will give you an immediate impression of how successful a composition may turn out to be. Looking at them upside down or in a mirror can reveal imbalances that may not be otherwise apparent.

▶ DIAGONALS

Here we see a level horizon at a pleasing six-tenths placement and further horizontal striations across the picture. But there is also a strong diagonal thrust in the two anchors, echoed in the tonal masses of the clouds.

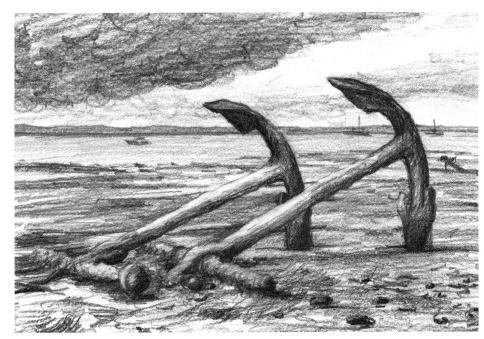

DISTILLED COMPOSITION

The further you develop your picture-making, the more you will come to appreciate the value of composition. To many artists, composition is the main ingredient of their work and all else is subservient to it. The following demonstration shows how a scene from real life can inspire a drawing of pure compositional form.

166

▲ This is a somewhat neglected city canal. It is not a scene of great beauty, but there was something in the curves and tree forms that caught my eye.

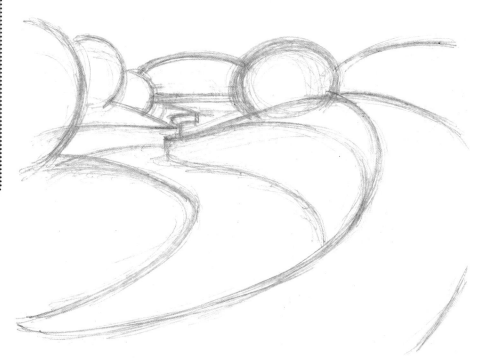

▲ Working from my photograph, I set about redesigning the scene as an ideal composition. I thought about the landscape features as abstract shapes and drew them as a set of pleasing curves on scrap paper.

▶ With a soft pencil, I roughly shaded the shapes to arrive at a set of tones that had a satisfying balance across the picture yet also gave the landscape features depth and solidity. It is important to keep a consistent lighting direction throughout, which in this case comes from the right-hand side.

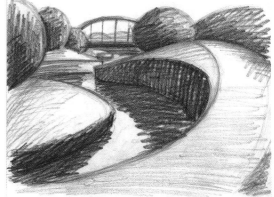

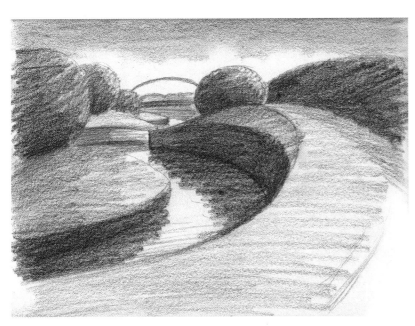

◀ Once I was happy with my tonal composition I took some fresh paper and redrew the scene. I used the side of a soft pencil to shade the basic areas of flat tone.

▶ With the basic tones established, I kept working over the whole picture, building up and adjusting the tones. I kept the texture very minimal, just enough to suggest a sense of difference in the surfaces. The result is a manicured, almost alien-looking landscape, worlds away from the scene that inspired it.

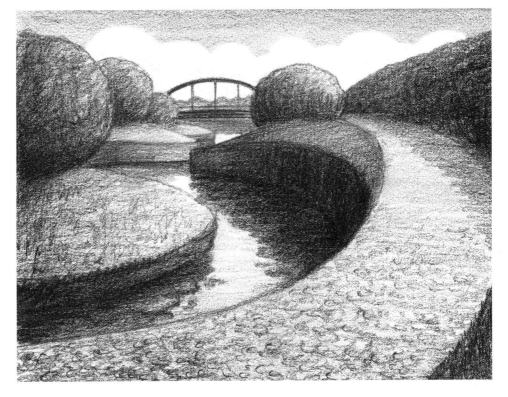

COMBINED COMPOSITION

Artists are free to interpret a scene or subject in any way that they please. Even when drawing a scene that exists in real life, it is common practice to omit certain details, move features around or adjust the relative scales within the picture. Whatever makes for a satisfying drawing is valid, just so long as you can make the alterations convincingly.

I stumbled across the scene on the right while on holiday and photographed it, thinking that the gently rolling landscape could make a useful background for an illustration. The kissing gate in the foreground put me in mind of a more picturesque version at a local church (above), which I later photographed to combine with my earlier scene.

▶ With a hard pencil, I drew the old gate, correcting the slightly distorted perspective of the photograph by straightening the posts to an upright position. For the background, I sketched the main shapes of the landscape features, exaggerating the curves of the hills and tree lines for aesthetic effect.

► With a dip pen and black drawing ink, I established the outlines of the gate and some rough shading, copying the lighting conditions of my source photograph. I also started working on some ground-covering foliage.

◄ With the foreground well established, I started work on the background. I loosely followed the tree forms of the photograph and made sure that I conveyed the same bright lighting and deep shadows of the foreground.

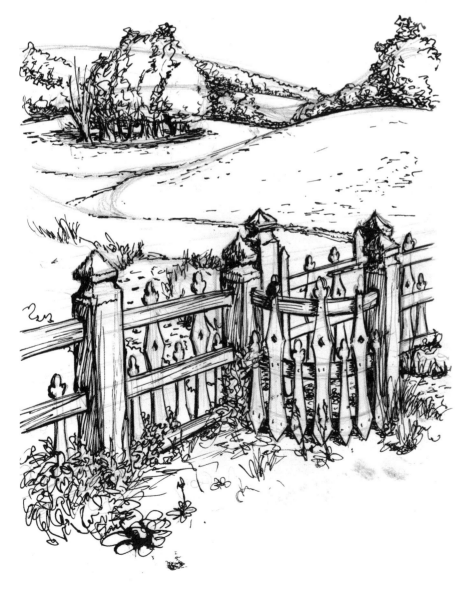

Combined composition (continued)

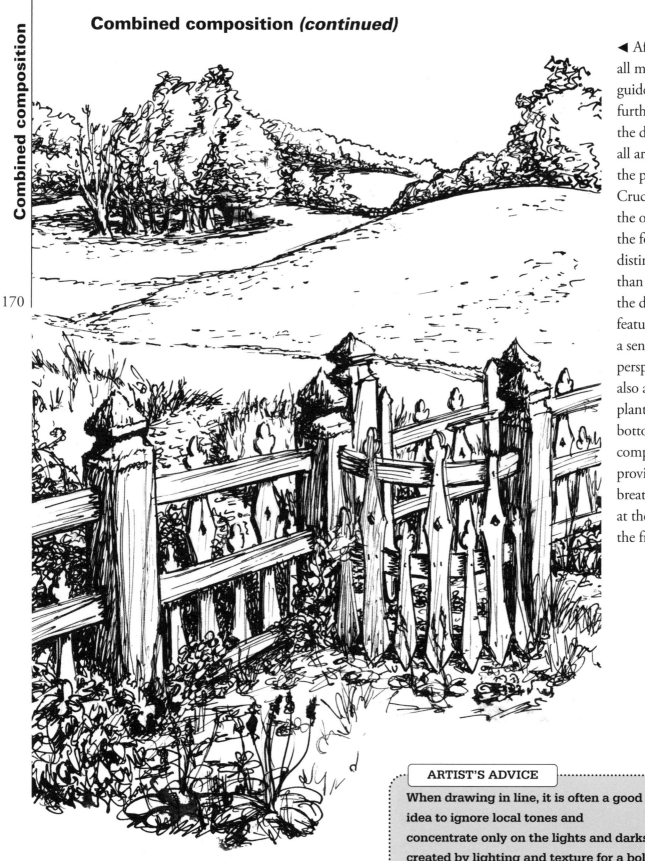

◀ After erasing all my pencil guidelines, I further refined the details in all areas of the picture. Crucially, I made the outlines of the foreground distinctly heavier than those of the distant features to create a sense of aerial perspective. I also added more plant life at the bottom to lift the composition and provide some breathing space at the bottom of the frame.

> **ARTIST'S ADVICE**
>
> When drawing in line, it is often a good idea to ignore local tones and concentrate only on the lights and darks created by lighting and texture for a bold, unfussy finish.

CONDENSED COMPOSITION

◄ With an imaginative approach to drawing, you can often find inspiration in even the most boring and familiar surroundings. When pondering a suitable subject for this demonstration, I needed to look no further than my own desk. Ashamed though I am of my untidy working practices, I thought I could turn this jumble into an interesting picture.

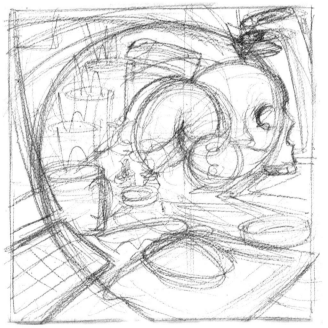

▲ Taking my cue from the seashell, I opted to base my drawing around a spiral – a common compositional device. I decided on a square format and drew the rough shape on some heavyweight watercolour paper.

▲ Without physically moving anything, I selected some elements of the scene so that they fitted within the forced compositional shape, just blocking them in roughly. For a really claustrophobic feel, I squeezed everything very close together, right up to the edges of the picture, and also allowed some lines to curve to follow the spiral.

Condensed composition *(continued)*

▶ In working up the detail, a number of changes presented themselves. I always try to keep a drawing quite fluid and open to changes all through the pencil stage.

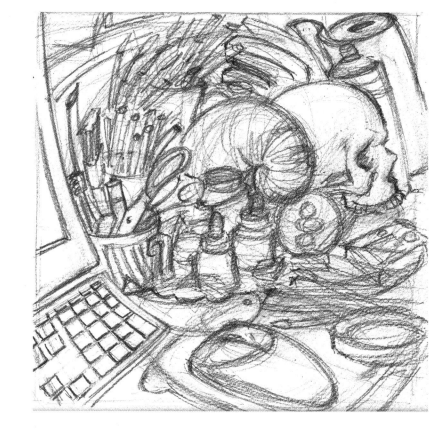

▼ Once I was content with the drawing I used brush and ink to set the outlines in place, adding lots of detail in ink without prior pencil work. Such direct inking helps to keep the picture fresh and stops it from looking overworked.

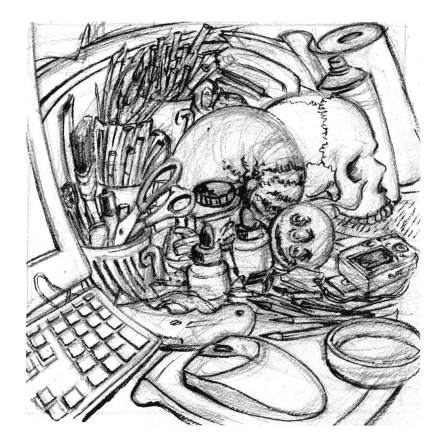

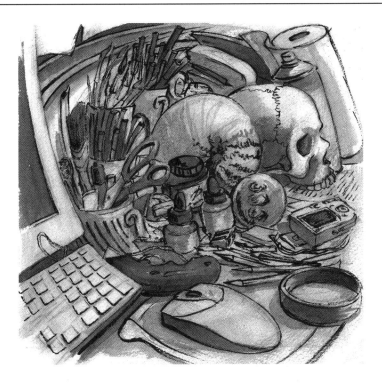

◄ After erasing the pencil marks, I mixed up some black watercolour into a thin wash and used a broad brush to roughly block in the areas of tone. For deeper tones I went over again with heavier washes, always aiming to keep the brushwork quite loose.

► In the finishing stages, I barely looked at the subject. Instead, I let the picture dictate what it needed for a good tonal balance and a sense of depth and solidity to the objects. With more black ink and watercolour I deepened the tones wherever necessary. Finally, I added some highlights in white ink with a fine brush.

COLLATED COMPOSITION

Another approach to picture-making allows the composition to grow as more and more features are added. A family outing to a farm park inspired me to assemble the following picture from various views of a recurring motif.

Having spotted goats on one picnic bench and chickens gathered around another, I pressed my family into posing on a third and photographed each from roughly the same angle and distance.

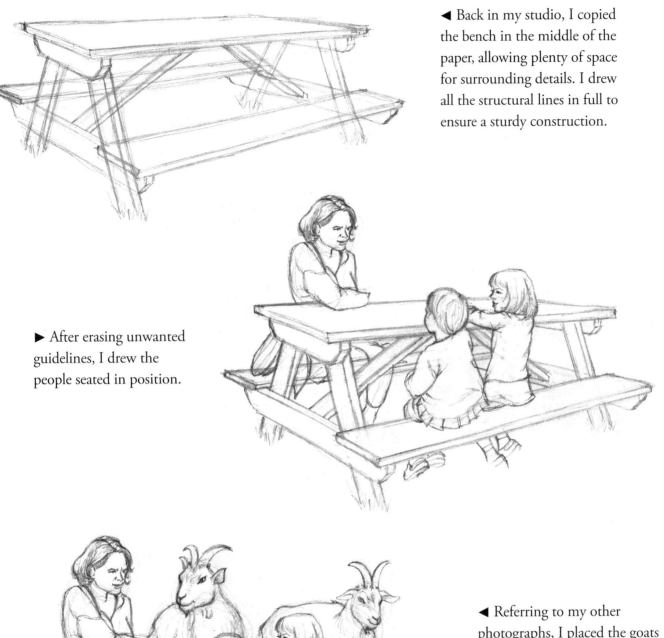

◄ Back in my studio, I copied the bench in the middle of the paper, allowing plenty of space for surrounding details. I drew all the structural lines in full to ensure a sturdy construction.

► After erasing unwanted guidelines, I drew the people seated in position.

◄ Referring to my other photographs, I placed the goats on the table and some of the chickens around the figures, deciding where they fitted best.

Collated composition *(continued)*

► By now I was having too much fun to stop, so I found pictures of other farmyard animals and crowded them around the scene. The cockerel in the foreground now looked too large, so I redrew him.

176

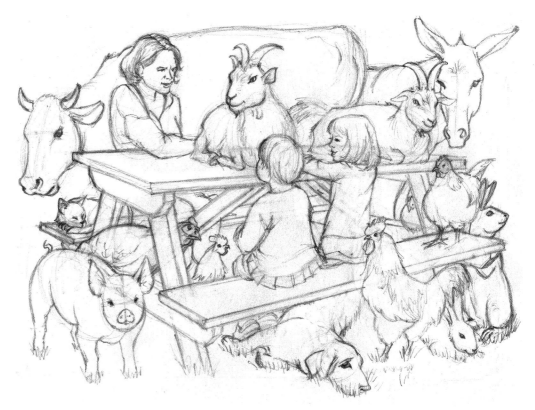

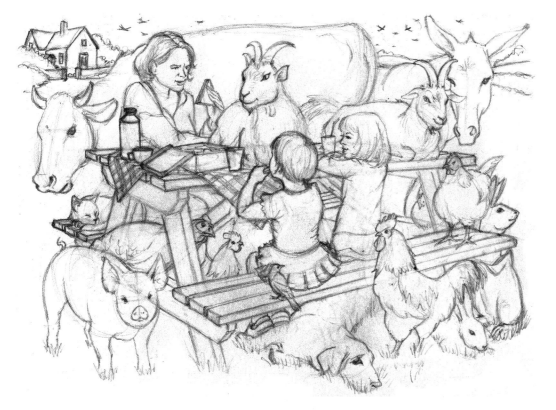

◄ To complete the scene, I drew the family's picnic and completed the detail of the bench. I also made up some background details to provide a suitable setting.

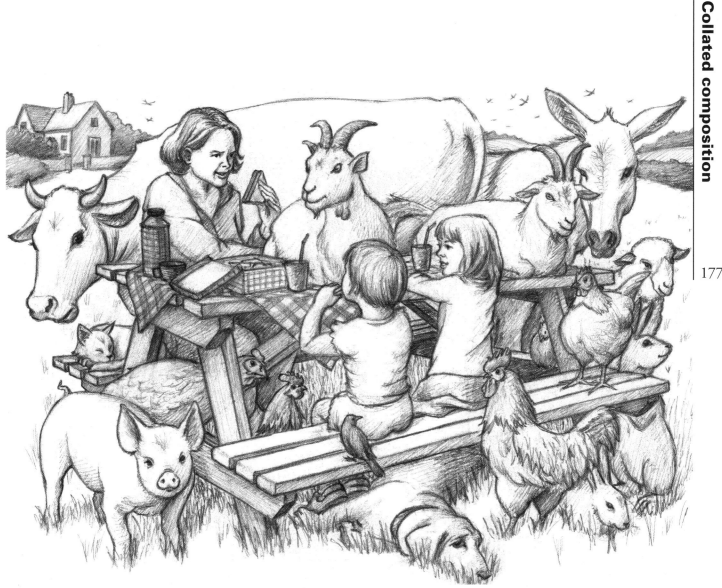

When adding extra elements to a picture, bear in mind the three-dimensional space that each new thing needs to occupy. If you try to visualize where the feet of either human figures or animals would meet the ground it will help you to place them convincingly and keep the scale of added elements consistent.

▲ Cleaning up and rendering this drawing took several hours of careful work with a fine mechanical pencil and the sharpened edge of an eraser. I was conscious of how easily the picture could become muddy and unclear, so I kept the shading to a minimum, only picking out a broad sense of shadow and avoiding much local tone. I added a sheep on the far right to fill a gap in the composition.

CREATIVE COMPOSITION

A scene from real life may be thought of as a mere starting point and changed in any way you can imagine. In this demonstration, I redesigned every element and changed not only the light source, but also the time of day.

178

◀ I thought this holiday snap contained all the elements of an interesting picture, but the composition is weak and the lighting is very flat.

▲ Having decided on a night-time scene, I used grey paper and sketched the main features in charcoal, starting with the scarecrow, which I wanted much larger in the frame. The other elements fitted in around him, changing in proportion or placement as I saw fit.

▲ I roughed in the main areas of shadow with charcoal, aiming for a tonally balanced composition that would be clearly readable. I then added washes of diluted black watercolour and white ink to build up the mid tones and the lighter mid tones, bringing some depth to the picture.

▲ Using any tool that felt appropriate – felt-tip, pencil, white pencil and more brush and ink – I sharpened up the drawing and added details here and there. A fine brush and neatly applied white ink lifted out some bright highlights, which gave the effect of moonlight.

FRAMING

As you have learnt, the arrangement of elements within the frame is one of the most important factors in the success of a finished picture. However, compositional options do not end with the completion of a picture; altering the size, shape and placement of the framing can bring an extra dimension to a work. You can also plan your pictures to work within a particular framing device from the start.

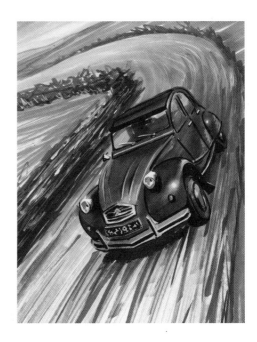

▲ TILTING

Altering the angle of a picture within its frame presents an unsettling image and suggests dynamic movement. Skewing this rather ordinary car picture seems to radically enhance the feeling of speed by making the road appear very much steeper.

▲ EXTREME CLOSE-UP

Closing in on a particular detail can have a concentrating effect, cutting straight to the heart of a subject. Sometimes a weak piece of artwork can be brought back to life by framing off the less successful parts to make a new, tighter composition.

▲ ABSTRACTING

Another way to salvage a failed picture is to frame it off as an abstract composition. I was never happy with this image as a portrait, but I liked the loose poster-paint brushwork. Excluding most of the recognizable features allows the viewer to focus on the tones, shapes and mark-making rather than the subject.

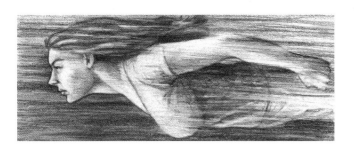

▲ ROTATION

A very different feel can result from turning your pictures around for presentation. This vertical figure from page 163, when turned on its side, suddenly looks rather like a superhero flying at speed.

▼ ► EXTREME FORMATS

Some subjects naturally demand more than the standard short rectangle picture area. The panoramic 'letterbox' format gives an instantly cinematic feel to quite mundane subjects. Similarly eye-catching, very tall formats exclude peripheral details from tall subjects and strengthen the sense of vertical distance.

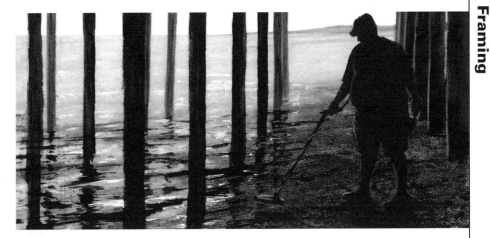

> **ARTIST'S ADVICE**
>
> Two large L-shaped pieces of cardboard laid on top of your artwork will help you to work out all the potential framing options before you make a final decision. There is no need to cut off the unwanted parts to present a new framing; instead, take measurements from your L-shapes and cut out a paper or cardboard frame to affix over the artwork.
>
>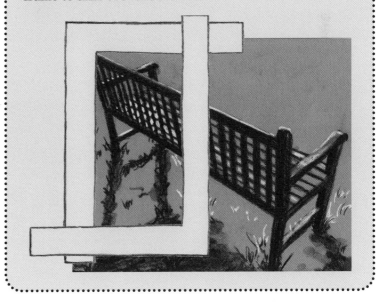

EMPHASIS

Whether you are drawing large, expansive scenes or modest individual subjects, there will be certain elements of your pictures to which you want to draw particular attention. There are many sophisticated ways to do this and we will explore them later in the book, but for now let us look at some simple devices for emphasizing the features of your pictures that you wish to be noticed.

▲ When drawing this old car I was struck by its sheer size, compared with modern cars. As a little joke for myself I sketched in an old lady behind the wheel, giving the car an immediate sense of scale, emphasized by her exaggeratedly tiny stature..

▲ To emphasize the texture of this rabbit, I ignored any anatomical detail and drew it as a simple ball of fluff. By making the head relatively lifelike (and not overly cute), the drawing reads as a fairly accurate representation. A tight cropping lends the creature a sense of bulkiness as it fills the frame.

▲ I wanted to make a feature of the fly's smallness. Placing the subject against another familiar object, the hand, we get an immediate feel for its size and relative vulnerability. And just in case the fly should go unnoticed, I used a 'starburst' effect to pick it out against the background.

◀ For this demonstration, I worked from a photograph of my wife taken on a memorably wintry day. I first drew broad shapes with the edge of a charcoal stump to establish the physical thrust of the figure. It was then quick and easy to draw more detailed line work with the charcoal's point.

▼ Here I added a few simple effects to emphasize the figure's exertion. Some blades of grass and a few strokes of flowing hair suggest the buffeting of the wind. With the corner of an eraser I lifted off the charcoal in diagonal strokes to form streaks of driving snow. To finish, I skewed the picture to give the impression of an uphill slope.

ARTIST'S ADVICE

It is advisable to err towards subtlety when adding effects to your drawing; it is all too easy to overdo things and end up in cartoon territory.

FRAMING

As you have learnt, the arrangement of elements within the frame is one of the most important factors in the success of a finished picture. However, compositional options do not end with the completion of a picture; altering the size, shape and placement of the framing can bring an extra dimension to a work. You can also plan your pictures to work within a particular framing device from the start.

▲ In the design of a clown's costume, nearly every part of the body is distorted in some way. The feet are comically huge and the bulky wig is emphasized by a tiny hat. Facial features too are exaggerated with make-up. Baggy or padded clothing hides the natural form of the body underneath. In drawing such a character you are, of course, free to further exaggerate any elements you wish.

▲ Designers and illustrators in the world of fashion routinely elongate the stature of the female form to comply with a certain ideal of beauty and grace and show off the clothing to its best advantage. Posture and contour are also exaggerated far beyond what is natural for even the tallest and most limber fashion models.

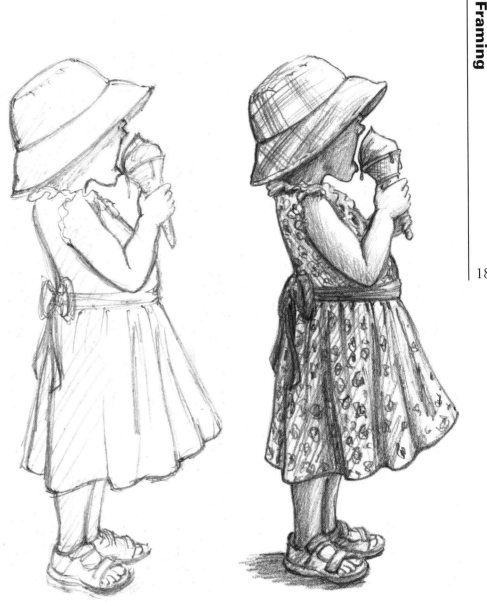

▲ Exaggerating form need not be so blatant as the previous examples and often works more effectively when applied with subtlety. To demonstrate, here is a sketch I made while my small daughter was engrossed in eating an ice cream. Supplying children (and animals) with food is a good way of keeping them still for the duration of a quick sketch!

▲ Back in my studio, I placed some thin layout paper over the original sketch and traced the original. In doing so, I enlarged the hat, ice cream and mouth, reshaped the belly and skirts and exaggerated the arch of the back. I also reduced the size of the hand to emphasize the large ice cream. None of these changes is very dramatic, but they add up to a more charming and characterful image.

▲ To convey the details convincingly, before rendering the drawing I referred again to my daughter's outfit. I decided upon a lighting direction and made the shadows quite deep to convey the brightness of warm sunshine.

The concept of exaggeration can be applied to many different aspects of drawing, depending on the subject matter and your intended take on it. The following examples show just a few of the ways in which subjects can be manipulated for effect.

▲ This sketch of a bronze statue shows how the sculptor has exaggerated the gorilla's proportions to convey muscularity and solidity in the greatly oversized arms and the sharply delineated contours of the back and buttocks.

◄ To capture the vigour of this cactus, I exaggerated its spiky, hairy and engorged textural qualities with varied and energetic pen marks. The contrast with the pot is important here: it is plain and methodically shaded, and greatly reduced in scale to emphasize the plant's dynamic growth.

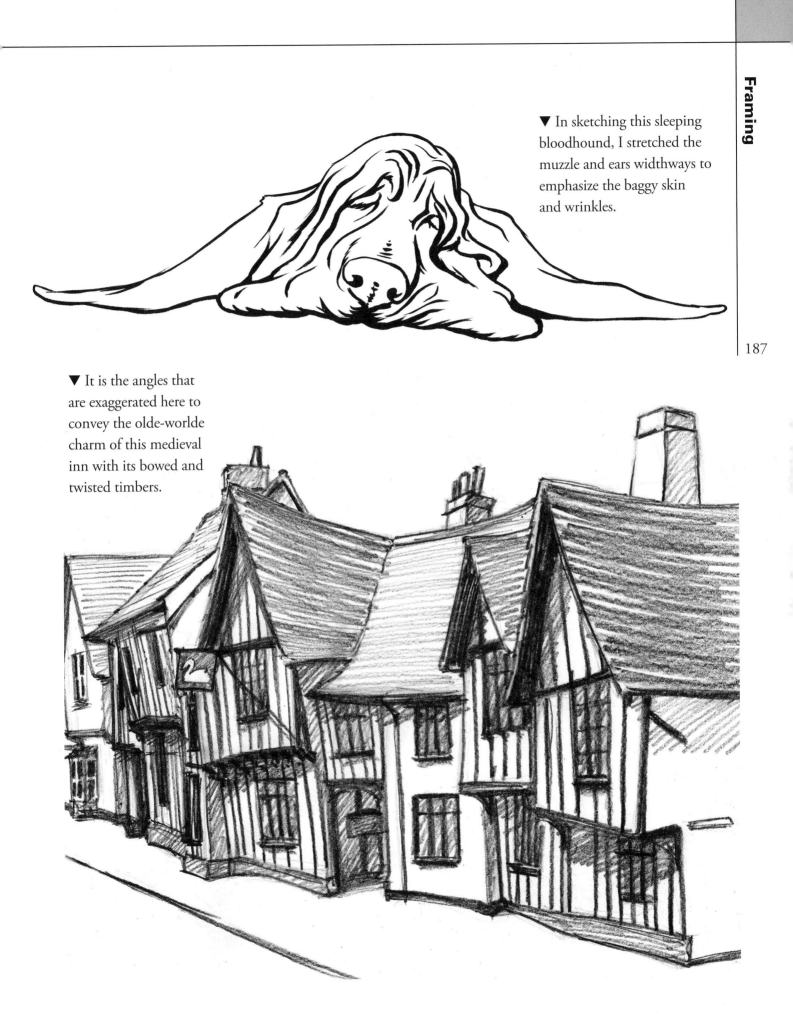

▼ In sketching this sleeping bloodhound, I stretched the muzzle and ears widthways to emphasize the baggy skin and wrinkles.

▼ It is the angles that are exaggerated here to convey the olde-worlde charm of this medieval inn with its bowed and twisted timbers.

PART IV: *Invention*

In the last section, inspiration for the drawings came directly from observing reality. With the experience gained from tackling real subjects in creative ways you can now proceed to drawing objects, scenes and figures that do not exist in the real world. That is not to say that we will not continue to explore real-life subjects – indeed, we will depend on them as much as ever to inspire and inform our flights of fancy.

The challenge of making drawings without direct reference to a subject should soon feel quite liberating as you come to appreciate the creative freedom your new-found skills will open up for you.

Essentially, the second part of the book deals with illustration. This is a very broad area that caters to many different age groups and markets, but the skills demonstrated in this section should allow you to develop your artwork in whatever direction suits your strengths and interests. We shall take the raw material of sketches, photographs and the imagination and turn them into pictures of idealism, surrealism, caricature and fantasy.

As you work through this section, bear in mind that the examples depicted represent only the tiniest fraction of all possible subjects, methods and stylistic treatments. Cast your net as wide as you can and study the work of artists and illustrators from many different periods and fields. Try to learn something from each, just as they learnt from their peers and predecessors.

ILLUSTRATIVE PROCESSES

Having gained some experience of drawing things as they are in the real world, it should not be too difficult to conceive new pictures in compositions and designs of your own invention, all from the comfort of your desk. Here is a breakdown of the typical stages involved in a simple illustrative design.

190

THUMBNAILS

The first stage is usually to produce a number of thumbnail sketches, so-called because they need be no larger than your thumbnail. The idea is to jot down ideas and compositions in an extremely quick and throwaway manner, without fussing over details. It is the basic essence of the design that matters, and this should be quite clear in small scale.

My brief for this job was for a bold, black-and-white design that conveyed the idea of growing vegetables on an allotment. My thumbnails, done on a piece of scrap paper, are virtually indecipherable, but they served their purpose for me.

◀ THE ROUGH

Still using scrap paper, I worked up my favourite thumbnail into a more resolved design and established a rough shading scheme. Taking a few minutes to work out ideas in rough form can save a lot of time and headache in the long run.

▶ In building up the detail of the drawing, I aimed to keep everything very simple for this bold design. Other types of illustration may require much more detailed underdrawing.

◀ To ink the outlines, I used a cheap black permanent marker pen. The heavy line of the pen forced me to retain that essential boldness of execution and also shaded the dark areas with a rich black. The waterproof ink would allow for corrections.

▶ Having noticed a tonal imbalance, I added more solid black on the barrow and fork. With a fine brush, I painted on white drawing ink to correct the other mistakes and imperfections and, once it was dry, I used the marker pen again over the top.

PURITY OF DESIGN

**Although most illustrative artwork tends to
be produced along the lines of the previous
demonstration, there is no definitive method.
Just as your choice of materials may determine
how you go about creating a piece of artwork,
so the type of picture or effects you aim to achieve
demand particular processes and ways of thinking.
The following examples came out of the processes of
successive redraftings and fine-tunings.**

It was not difficult to draw the individual silhouettes that make up this design; they are
virtually straight copies from old photographs. However, arranging them into a clearly
legible and appealing composition was not so straightforward. I drew each on separate
sheets of tracing paper and overlaid them in many different positions. Once happy, I
stuck them in place and traced the design on a lightbox.

TRACING

For working through the stages of the design process, much time and effort can be saved by tracing. It requires no dramatic redrafting at any stage and allows the work to develop quickly and painlessly. I often use layout paper, which is cheap and lightweight enough to trace through but more opaque than tracing paper.

Here I started with a naturalistic sketch and placed a sheet of layout paper over it. As I traced, I modified the drawing into graceful curves to give the animal a more powerful presence. I repeated the process, this time adding a sense of movement.

When I was pleased with the design, I used a lightbox to lightly trace the outline onto firm paper and stippled the shading with a sponge and poster paint.

DECORATIVE ILLUSTRATION

The principles outlined so far in this chapter may be taken a step further into artwork that is purely decorative in function. Fabrics, wrapping paper and all manner of everyday items carry decorative motifs that originate from real-life subjects. For this demonstration, I followed the principle of reducing a subject to a kind of symbol of itself and then reinventing it to suit a particular space.

194

▲ Initially I sketched various poppies in the garden to get a feel for the way they are constructed. I also drew a leaf and some stems and buds, all of which add to a flower's particular character.

▲ I picked a completely arbitrary shape and sketched a pleasing curve running through it. To this I added the very basic forms of some flowers and leaves.

▲ Over my basic guidelines, I started to flesh out the forms of the flowerheads and leaves. I was interested here in filling the space evenly while retaining a very loose flavour of the poppy forms I had sketched.

▲ In order for this design to look 'pretty' I wanted to draw every part in detail before committing anything to ink. The result is quite messy, so I made a fresh tracing of this design onto good-quality, clean paper using a lightbox.

◄ For the first stage of inking I employed the even line of a felt-tip drawing pen. As you can see it looks very weak, but it is amazing what a difference can be achieved by well-considered secondary inking.

► With the same medium drawing pen, I went over the lines to give them more weight and grace in their curves. Some solid black gave a focus to the two blooms and distinctive fuzzy marks helped the stems and buds to stand out. Some background dots (rather like poppy seeds) lifted the whole design forward, and then I added some more striations on the leaves, which seemed rather too flat and featureless. To finish, I further strengthened the perimeter to contain the design as a whole.

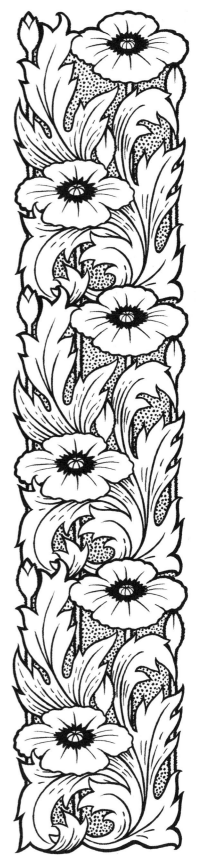

► Designs like this can be repeated, using a computer or a photocopier, to make friezes, borders or other decorative schemes.

METAMORPHOSIS

Another way of producing imaginative drawings involves developing your ideas directly on the artwork. Often the best results come when an interesting form presents itself and naturally suggests a path to follow. It is best to work with materials that are easy to erase, but most materials can be corrected and reworked when you have gained experience of using them. For now, though, I will demonstrate this approach with pencil, making a drawing based on an old tree that, to my mind, had a very suggestive form.

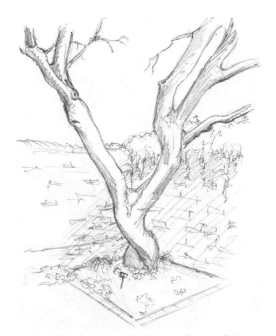

▲ First I lightly sketched the basic form of the tree and its immediate surroundings. It is a good idea to work from a naturalistic starting point and not impose your vision too soon in the process.

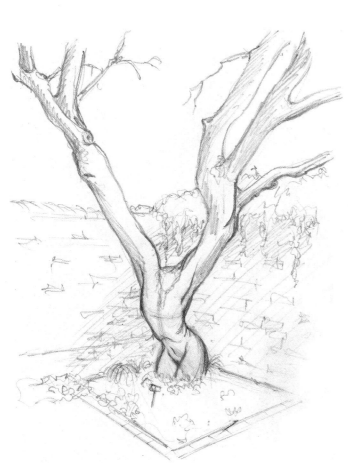

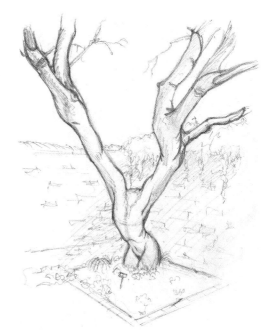

▲ With a darker pencil I picked out the parts of the trunk that most suggested a human torso and gently emphasized the contours accordingly.

▲ I carried on the process up the limbs, which ended in oversized and twisted hand forms. I let the form of the tree dictate all of these changes, trying to incorporate each branch into the design. I imposed the human details out of my head, informed by my experience of drawing the human figure from life, and also carefully observed my own hands.

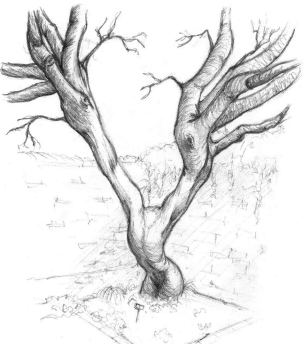

◄ For the shading, I followed the lighting direction present. I used curving, scribbly marks to give solid form to the branches and to convey a convincingly tree-like texture.

► I shaded some background detail to provide a setting and tone for the tree to stand out against. Tight cropping truncated the branches at convenient points to help with the illusion of fingers. As a final touch, I added the detail of a thrown-back head, inviting an emotional connection with the viewer.

BEYOND REALITY

In the world of the surreal, everyday subjects take on qualities they could never possess in real life, yet the recognizability of the motifs lends the imagery a degree of credence. This is the language of editorial illustration, usually contrived to make a point, but equally adaptable to pictures that exist for no other purpose than to intrigue. The only restriction is your imagination.

A simple and effective introduction to making drawings of invention and fantasy is to combine unrelated subjects in a single drawing. There is no end to the different approaches you can employ to achieve such metamorphoses and there is much fun to be had.

▲ We generally associate power and importance with physical stature. Enlarging familiar objects will increase their standing relative to the things around them, and the reverse is true of reductions in scale.

▲ Creative juxtaposition is essentially about bringing two (or more) unrelated things together to create meaning, comedy or visual impact. The concept is extremely simple, yet in practice it can be very effective.

▲ It is easy to apply a surreal element to anything you draw; it need not be clever or polished in its execution to have impact. I drew this on a bus after biting into an apple, referring to my own teeth in the reflection in the bus window.

▶ Repeating a motif can change the connotations of a single image. Here I painted one figure and then replicated it over many layers on a computer.

▲ Every law of physics may be turned on its head by the artist; the only rule is that you should make your pictures look believable. So whatever combinations or manipulations you employ, the drawing language, lighting, perspective and so on must be consistent within the picture. In this case, the consistent ground plane and interaction of shadows are the important factors.

◀ A suit may walk unaided without any logical means of propulsion. But then other times we may allude to the implausibility of an image, for example by including some sparkle effects to suggest a magical element.

ANTHROPOMORPHISM

It is a human trait to imbue all sorts of non-human objects with human qualities and values, a phenomenon known as anthropomorphism. This can be done as simply as by drawing a face on the front of an object. The illusion of life can be further developed with character and expression in the face and an appropriate sense of movement or action. With human limbs and articulation, the presence of a face may not be necessary at all.

▲ It takes no great leap of the imagination to see the face implicit in this bulldozer, and no more than a few strokes of the pencil and eraser to turn it into a friendly character.

▲ Humanizing animals involves adapting their natural features and characteristics rather than inventing them. A creature may be drawn in quite naturalistic proportions yet convey a sense of humanity with the simple addition of a human facial expression, in this case a smile. A smooth and rounded drawing style also helps to convey friendliness.

▶ Here we see the animal fully clothed and performing human tasks. He is also standing upright and using his paws as if they were hands.

◀ In this design, the animal is almost entirely human in action, character and proportion. It is no more complicated than a cat's head drawn on a human body, yet we still accept it as essentially a cat rather than a deformed man.

MAKING FACES

Over the next few pages we shall be looking at ways to manipulate the proportions and features of the human head for caricatures and characterizations. However, before you can break the rules you must first be clear what they are, so the first step is to learn some basic guidelines that can aid you in drawing the head in its natural proportions.

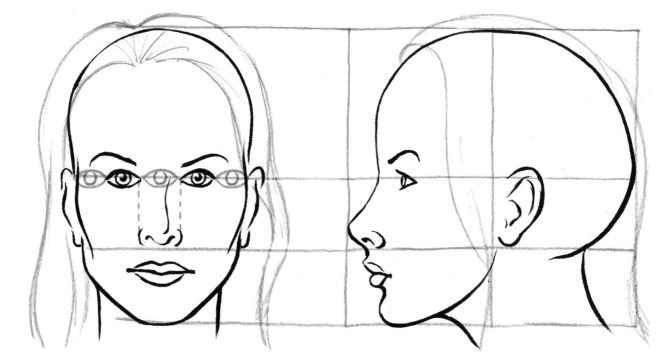

▲ Although every face is different, the basic proportions follow some general rules. The eyes sit about halfway down the whole head and the bottom of the nose and ears sit about halfway between the eyes and chin. The head is about five eyes wide and the nose about one eye wide at its base.

In profile, the head is broader, fitting roughly into a square with the ears set back about halfway. Note here the altered shape of the eye and the angles at which the lower face and neck recede.

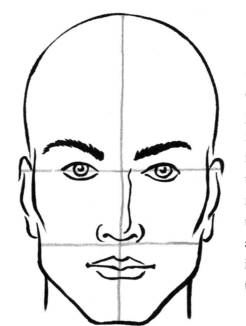

◄ Male faces follow exactly the same relative proportions but differ in the contours of the features. The brow tends to be heavier, the jaw more angular and the neck thicker set. The eyes, nose and mouth may be subtler in their variation from those of the female face.

In practice it is much more common to draw faces turned and tilted. The same guidelines can be employed for any angle of view, but they must be drawn to wrap around the egg-shape of the head. Bear in mind that when seen from above, more of the forehead is visible so the horizontal guides should appear lower down the head, and when seen from below the opposite will occur. Likewise, the ears appear to move up and down on the head according to the degree of tilt.

ARTIST'S ADVICE

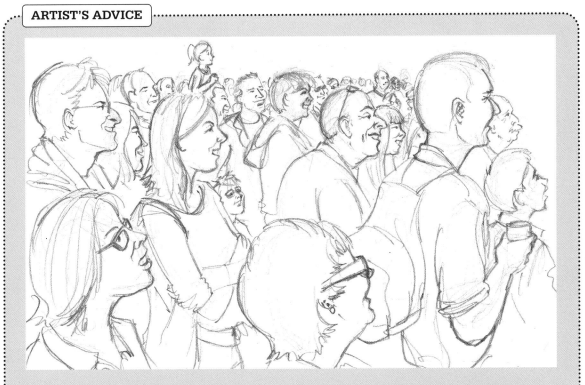

While this crowd was concentrating on a street performer, I was free to draw them at my leisure. There is no better way to get a feel for all types of faces than to draw lots of them. Carry a small sketchbook and draw faces in coffee shops, on buses and in libraries, for example.

STYLISTIC PORTRAITURE

The test of drawing faces is to achieve convincing likenesses of specific people. In itself, this can be a tricky business; some likenesses come easily while others may elude repeated attempts. Even so, in the spirit of this book, you should set your ambitions that little bit higher and aim to introduce a creative element into the faces you draw. One way to do this is to think carefully about what drawing language or style may be appropriate for a subject.

204

▲ For the actor Christopher Reeve, I have adopted the graphic comic-book style in which his Superman character is typically portrayed. It is not always easy to decide where to put the dividing lines between pure black and white, but it helps if the subject is brightly lit.

▲ To capture the wiry, wizened face of Clint Eastwood I did the inking with a fine felt-tip pen, allowing it to wander across the underdrawing and build up the modelling through the wrinkles.

◄ Fittingly for his period and profession, I depicted Charles Dickens as a carved wooden bookend. This is a straight copy of a contemporary portrait rendered with tones and highlights that are consistent across the whole surface.

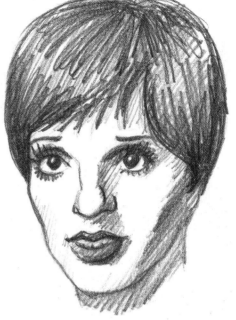

► As you can see from my quick pencil study of Liza Minelli, her hair and makeup are very distinctive and accentuate her large eyes and round face. Tracing through onto layout paper, I streamlined the outlines to turn her face and features into a series of symbols.

◄ Inking with pen and brush, I further stylized the image. I ignored any naturalistic lighting and turned the highlights on hair and lips into the same kind of zigzag patterns as her fringe and eyelashes. Though I have not altered the proportions or placement of any features here, the dramatic simplification and redesign means this drawing almost counts as a caricature.

CARICATURE BY STRETCH

Much of the practice of caricaturing involves such intangible things as experience, feel and trial and error. Just as every face and personality is unique, there are no hard and fast rules, but there are some general principles that can get you started on this rewarding discipline. Here I will discuss stretching the proportions of the head and features in a controlled direction.

The principle of stretching features can be used in a variety of directions. For this profile of John Lennon, I moved the layout paper laterally as I traced my original sketch, keeping the placement of the features consistent with the aid of horizontal guidelines. I then traced the tracing in the same way until I was happy with the exaggeration. The back of the head is of little interest in a caricature and I drew it much diminished in size.

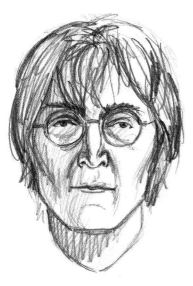

◄ To get a feel for the front view, I looked at many photographs and made a quick sketch. The prominent features for me were the chiselled nose, thin lips and general angularity of the face.

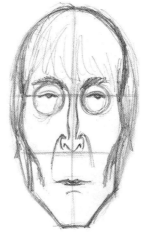

◄ To start a caricature, I drew a rough grid, greatly elongating the lower face to accommodate a lengthened nose. Onto the grid, I roughly put the features in their new placements and made a start on shaping the cheekbones and jaw.

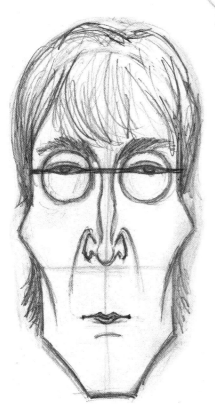

◄ At this stage, it is all about feeling your way into the characterization, reshaping, refining details, erasing and pushing the exaggerations, all the while striving to retain a likeness. Do not be afraid to let your drawing get quite messy while you search for the optimum outlines and contours.

► Somewhere along the way an appropriate treatment for the final image will usually occur. In this case, I elected to continue with the pencil version. I carefully cleaned up the many scruffy marks and shaded with a soft pencil in selected areas to emphasize the angularity of the newly constructed face.

STYLISTIC FIGURES

The full figure offers yet more potential to make artistic statements about people. Working from photographs or live models, sketches can quickly be developed into exaggerated takes on a subject, just as we saw with famous faces (pages xx–x). Of course the possibilities are endless, but there is always something distinctive about every individual that suggests a way forward. Here are two different approaches on a similar theme.

208

◀ It was the odd, round-shouldered posture of this guitarist that caught my eye, but I failed to capture it successfully in my initial sketch.

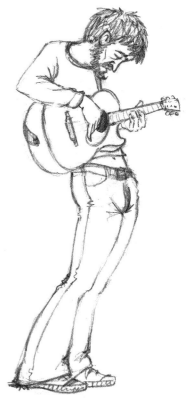

▲ My first step in developing the pose was to draw a sweeping curve to build the figure around on my layout paper. This is known as an 'action line', more common in drawing dynamic figures, but equally useful as a guide to a static posture.

▲ I traced the figure to follow the action line, moving the paper as necessary.

▲ With the basic figure in place, I could have a bit of fun redrafting parts of him into a more intense, undernourished hippy type.

◄ The feature of this figure that stood out for me was the way the guitarist curled himself around his instrument.

► As I traced through onto layout paper, I moved the paper around to follow pleasing curves and exaggerate his posture.

▲ With the second tracing I further refined the forms, making them conform to a series of curves that ran into each other.

▲ Happy with the overall balance and rhythmic flow of the design, I committed it to ink, tracing again onto fresh paper using a brush pen.

INVENTED FIGURES

Having learnt to conjure up faces and characters out of the imagination, it is likely that you will want to develop them further by giving them bodies. The human figure is a complex machine; complex in its structure and proportions, its range of motion and gesture, and its diversity of build. But in essence, bodies can be simplified down to a basic framework that is common to all, much like the egg-shape with which we begin a drawing of the head (see page xx).

210

◄ Before drawing a figure without reference to a model or photographs, an illustrator will first draw a basic working skeleton: ovals for head, ribcage and pelvis, all the main joints, and, crucially, the spaces and angles in between. The skeleton should carry all the necessary information about proportion, pose, body language and perspective.

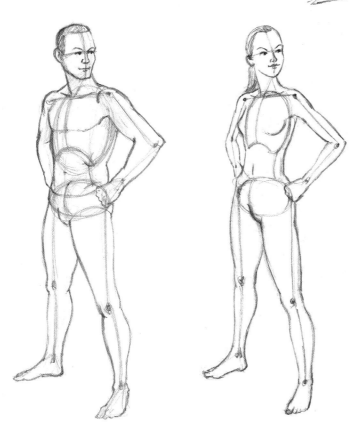

▲ The task of fleshing out the skeleton into a convincing figure should be relatively easy. So long as the skeleton is well posed and proportioned, the odd stray contour will not be very noticeable. Pay particular attention to heads, necks, shoulders and hands – not only are these the most visible parts of the clothed figure, they are also the parts that are most often drawn incorrectly.

▲ Exactly the same skeleton can be used to draw adults of different builds and sexes. You can broaden the ribcage and hips for a very heavy figure, but the skeleton's pose and proportions remain generally the same.

Regardless of height, build and sex, adults are generally the height of around seven or eight of their own heads. Children of ten may be more like six heads tall and toddlers are typically about five heads tall. Artists and illustrators measure figures on this scale to maintain consistency of proportion within each figure. You may like to refer to this diagram when constructing figures of your own. You can see at a glance, for instance, that a man's shoulders are roughly two heads wide, a child's legs three heads long, a woman's legs four heads long, and so on.

COSTUME AND CHARACTER

Learning to draw figures from the imagination is all very well, but for them to serve any artistic function they must be given personality and purpose. Unless you want to appeal to certain niche markets, your figures will first need to be clothed. Dressing a figure is not so easy as it may seem. With experience, you will be able to draw clothed figures straight from a skeleton, without going through the nude body stage, but the task is aided greatly when you have a good idea of the contours of the body underneath.

▼ Here are the figures from page 210, each clothed unconventionally to demonstrate the effect of costume on our perception of character. These costumes also represent the main types of fabric you will need to develop a feel for.

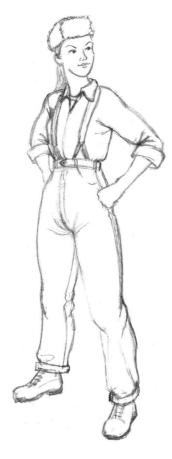

▲ Lightweight, floaty cloth such as silk or muslin falls into large folds and tube-like structures, which are pulled downward by gravity.

▲ Heavy and stiff material forms large folds and retains creases. It may pull tight on the outsides of joints, but otherwise it generally sits loose and baggy around the body's form.

▲ Tight-fitting, stretchy fabric closely follows the form of the body. Where it wrinkles inside joints, the folds are small. Any seams and flaws are likely to be quite visible.

◄ As with so many aspects of drawing, a simple approach to costume can be very effective. If you can capture the right feel for a style of clothing, close attention to folds and wrinkles can be sidestepped altogether. In this illustration of Jeeves and Wooster the clothing is little more than a few outline shapes, but it reads as convincing period costume.

ARTIST'S ADVICE

It pays to do some research into costume. Finding photographs and illustrations to refer to will nearly always reveal some odd details and props that would not otherwise occur to you. Hairstyles and small details can add a great deal to an authentic characterization.

◄ Simplicity of design does not come without some rigour, however. The underdrawing demonstrates how I initially drew the clothing in detail to ensure that the resulting silhouettes and arm positions would work.

CHARACTER AND EXPRESSION

Drawing figures from the imagination is a challenge in itself, but there is yet more to consider when infusing them with life and character. Not only must poses express the right actions and attitudes, but they should be supported by expression and characterization.

▲ The experience of drawing real faces, through portraiture and caricature, can be employed in inventing new faces and giving them character and expressions. Diverse though people are, many do fit into easily discernible types, which are often used in illustration and cartooning as a kind of character shorthand. Drawing types is a great way to practise capturing expressions, whether overstated or subtle, and will also build up your repertoire of stock characters. In many fields of illustration this is a requirement. It is also rather enjoyable.

► It is not always easy to make figures interact physically with each other and their environment. Constructing a scene like this may require lots of small adjustments before taking it to final artwork.

ARTIST'S ADVICE

Keep a mirror on your desk and observe yourself making the expressions you want to capture in your characters. It is not difficult to transfer your expression onto different features and they will be all the more believable for it.

▼ Apart from working hard on the costumes for this scene, I also tried to give each figure a distinct personality through pose, gesture, expression and of course their facial features.

DRAMA AND NARRATIVE

Drawing figures in a setting with interaction between the elements inevitably generates an implicit narrative. At heart, that is what much illustration is about – telling stories. A visual story may depict a single moment in time, but then all the details you choose to include add to the background story or meaning of an event. Other narrative illustrations may show a single scene from a larger story or aim to summarize a whole book in one telling image. In any of these cases, the illustrator can get the most out of the subject matter by emphasizing the action or emotion to create drama.

216

▲ Macabre images of fear, torment, and evil deeds are bound to arouse the interest of the viewer. A sinister figure will add to the intrigue, especially if he or she is shrouded in darkness or otherwise hidden from clear view.

◄ There is not much going on in this image, but we know exactly how the man feels from his expression and pose, along with the high viewpoint, which has the effect of making him seem small and suppressed. The overflowing desk and ringing telephones also give us clues to his general situation or background story.

▶ It does not take much to get people guessing, and once questions are raised, they are naturally keen to know the answers. Just like storytelling, an illustration can set up a sense of mystery and embellish it with an appropriate atmosphere. Intrigue is an important tool when the aim of an illustration is to attract readers to a story or article.

◀ Bright lighting against a dark setting is a great way to focus attention where you want it, but there is much more to be gained from bold lighting. It can be effective in creating atmosphere, mystery and horror, and brings a sense of gravity even to playful images such as this.

A SINISTER ILLUSTRATION

Organizing all the elements that make up an illustration can take a lot of redrafting, especially when there are clients involved who have their own ideas. The following demonstration is typical of the kinds of stages a design may go through. The brief for this CD cover called for a sinister figure and black cat in front of a full moon and burnt-out building.

▲ The client decided to combine elements of each rough and to give the cat greater prominence in the scene. I drew a simple revised rough to ensure that everything was approved before committing to final artwork.

▲ Having done many thumbnails, I chose the best to work up into rough compositions for the client's approval. I gave each of the elements a similar weighting in the scene and left areas of undetailed space to allow for a title and other lettering to be dropped in later.

► Because dark and light would be so important in this picture, I produced a tonal rough for my own reference. This quick chalk and charcoal version allowed me to check that the picture would work in terms of legibility and tonal balance.

▲ The tonal rough showed me that the cat's body occupied too great an area of the picture and that its pose was looking clumsy. In redrafting the scene for the final artwork, I changed the pose and the naturally lower position of the head allowed space to include a suggestion of a building in the background.

◄ With brush and black ink, I outlined the main details and filled in areas of solid black. This meant covering over some carefully considered drawing, but it would make for a more confident image in the end. While the brush was still loaded with ink, I dipped it in water and roughly painted some background detail and surrounding tones with grey wash. This encouraged speedy work, which would help to avoid an over-laboured final picture.

A Sinister illustration *(continued)*

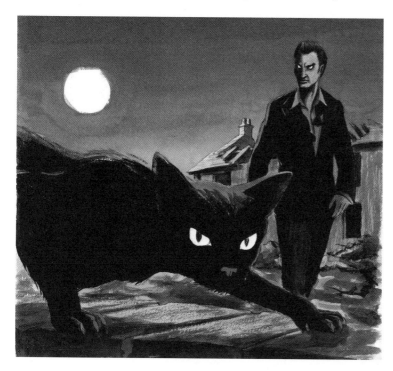

◀ To fill in the sky, I turned the drawing board upside down and rested it at an angle on my lap. With a very soft, broad brush, I washed diluted ink in horizontal strokes over the sky, starting at the horizon. The pigment gathered towards the bottom of my working area, resulting in a gradated tone. With practice and care this can be achieved seamlessly, but I only needed a rough finish here. I also filled in more tones across the whole picture, leaving no white except for the very brightest spots.

▶ To paint the clouds, I loaded a thin bristle brush with dark grey ink and then wiped the brush almost dry on some tissue paper to produce wispy, soft-edged marks. I dry-brushed with white ink for the highlights on the clouds and on the cat.

I spent some time on a few remaining details, building careful layers of watercolour in the man's face, modelling the cat's paws and washing a hint of gradated tone on the eyes. With pure white ink and a fine brush, I added the sharp highlights around the man and building and finally the cat's whiskers, white in the moonlight and black in the shade.

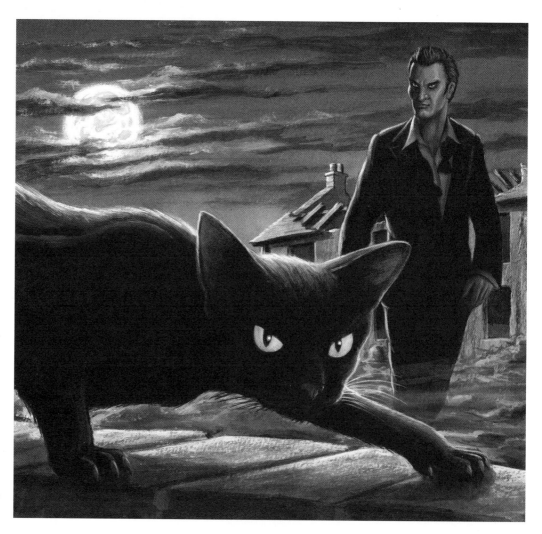

DEVELOPING A SCENE

So far, most of the imagery in this section has grown out of thumbnails, roughs and careful underdrawing, but some kinds of subject matter may be better approached in different ways. In this demonstration I allowed the composition to develop through the painting process. Remember that there are no rules governing how an image is produced; it is the end results that matter.

► The very loose brief for this illustration dictated only a ship at sea being attacked by a many-tentacled monster. Working from a photograph of a ship, I drew it roughly in charcoal straight onto heavyweight watercolour paper. Setting the ship at a diagonal breaks up the picture space dynamically and suggests a suitably stormy sea. As I added the tentacles and smoke, I shaded them with the charcoal and very quickly had a full tonal drawing to respond to.

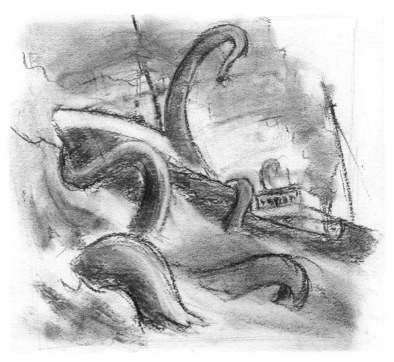

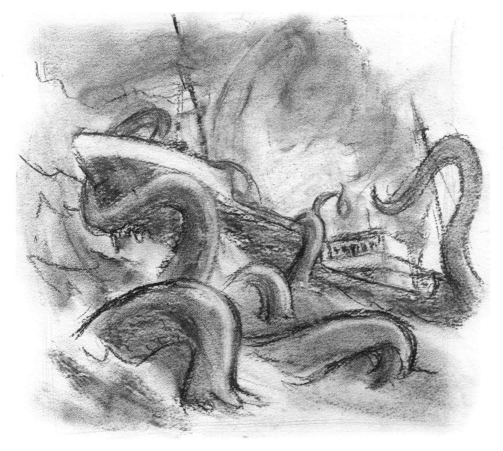

◄ Charcoal being so unstable, it was easy to smudge away some of the tentacles with a fingertip and draw new ones until I was happy with the composition. The dirty marks all over the paper would soon be absorbed into the painting.

►

Developing a scene *(continued)*

◄ Using a fairly large bristle brush (No. 5 hog's hair filbert), I blocked in the main areas of tone with washes of black watercolour, covering the paper loosely and quickly.

222

► I decided to make the tentacles more alien-like and took inspiration from pictures of entrails. I added the new drawing with white water-soluble pencil. To correct the perspective on the boat I mixed some paint with white ink, which is opaque enough to cover well. I also used white ink to brighten the sky around the cabin and to introduce some highlights in the clouds and sea.

◄ With all the elements established, I painted in the tentacles and added details on the ship with paint, inks, and water-soluble pencils. With experience of using a variety of materials it becomes instinctive to take advantage of their particular qualities for certain effects.

▲ To finish, I adjusted some tones here and there with watercolour washes and used more white and grey ink to add the splash and spray effects, before framing off the picture into a neat square.

HEROIC CHARACTER DESIGN

With the last two demonstrations we are veering into fantasy illustration, a term which encompasses a broad range of fictional traditions and styles as well as the more typical worlds of science fiction, dragons and wizards. Whatever the subject matter, the principles are interchangeable.

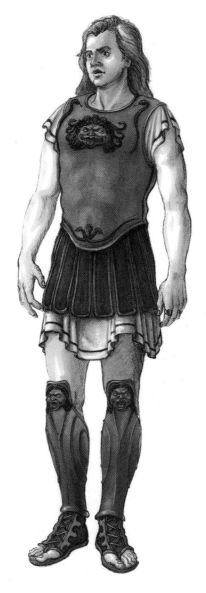

▲ A figure who is endowed with superhuman build need not be depicted in an overly macho or dramatic manner. Elegance of proportion can lend a character presence without the need for pantomime gesture.

▲ Where the standard heroic fantasy figure differs from an ordinary person is all in the proportions. As we saw on page 211, most adults are around seven heads tall, whereas the hero may be eight, nine, ten or more heads in height. He will be broad at the shoulders and narrow at the hips and his muscles will be bulky and well defined.

◄ Everything that applies to male heroes goes for women too. Female warriors, superheroes and the like will be eight or more heads tall, well-muscled and heroic in pose and expression. Others may be more feminine and elegant, but nearly always impossibly tall, much as in the world of fashion illustration (see page 184).

► You are not obliged to keep to the well-worn conventions of heroic characters. None of this is real, so let your fancies run free. Think of your characters as people with personalities, tastes, flaws and background stories. Who is to say that imaginary heroes cannot be old, educated and suave, or possess any other quality the artist chooses to give them?

ARTIST'S ADVICE

Because so much of a person's character is shown in the face, beginners tend to draw heads rather too large for heroic characters. A heroic character who does not look suitably imposing may in many cases be corrected by simply reducing the head rather than reworking the entire body.

OTHER FANTASY CHARACTERS

As well as heroes, fantasy stories abound with all manner of figures of wit and mischief – far too many to cover in the limited space of this book. However, the following examples can be adapted to suit many diminutive character types, the differences often being merely in the final details.

226

▲ Two very different characters can be seen in these skeletons. Both are around five heads tall, but one is very much broader in the head, chest and shoulders, his build being somewhat reminiscent of a bulldog or gorilla. The posture of each gives them attitudes appropriate to their builds.

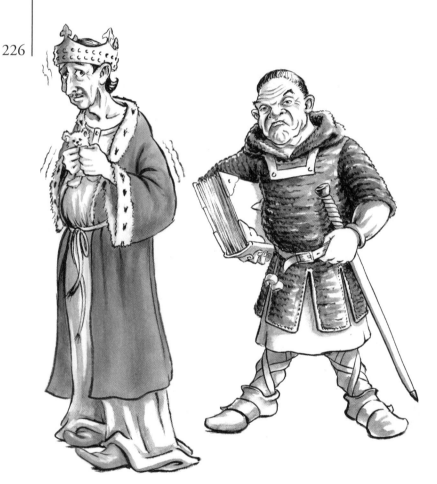

▲ In working up the design of these characters, I looked into medieval costume and adapted it to suit. This kind of research nearly always throws up ideas and results in more convincing images. Here, the characterizations and attitudes mirror the relevant body types. However, it would be equally valid, and perhaps more interesting, to invert those conventions.

ARTIST'S ADVICE

Even when you intend to drape a character in heavy robes, it is always advisable to draw the whole figure in skeleton form at least. This ensures convincing dimensions, balance, pose and characterization as well as providing clues for the hang of the clothing.

◀ To give this perky little chap a degree of energy in his pose, I started with a strong action line to run through the whole body, and built the skeleton around it. The proportions, at around five heads tall, are similar to those of a small child, but overlarge hands and feet help to make it seem more adult from the start. Already a sense of character and expression should be apparent in the skeleton.

◀ The face being so important in quirky characters, I drew this first. This would influence my drawing of the rest of the body. In roughing out the main masses of the body, I reduced the ribcage and hips, which are now much smaller than the head.

▶ In adding clothing and refining the details, I decided to change his left arm. Introducing a pencil, an object of recognizable size, establishes a sense of scale.

▶ After a few more tweaks the figure was ready to be turned into a final artwork, in this case using black ink and a couple of shades of grey marker pens.

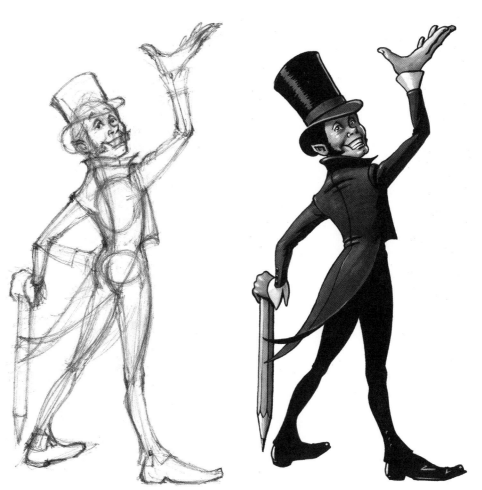

NON-HUMAN CHARACTER DESIGN

Folklore and mythology are alive with superhuman beings and fabulous beasts that have been a rich source of inspiration for artists and illustrators over the centuries. Nowadays, such creatures are generally only found in children's stories or fantasy adventure comics and films. As such, the whole genre is often overlooked, or looked down on, by 'serious' artists, but there are few subjects that offer such scope for invention and genuine enjoyment in imaginative drawing.

◀ Try to keep your options wide open and let the drawing develop as you go. It is probably best not to start with a skeleton because that would tend to make the proportions and the pose too rigid; it is preferable to find a random seed of inspiration and get some marks down on paper. As a starting point for this design, I very roughly sketched the form of a standing chimp, copied from a photograph, using a hard pencil.

▶ I did not want this design to end up looking like a chimp, so I started to play with the posture and form, increasing the arch of the back, pushing the head forward and so on. It is useful to generate a tangle of lines like this to keep the design fluid and prompt ideas.

▶ With a softer pencil, I selected the contours I liked out of the myriad guidelines. After erasing around the edges I was left with a fairly clear outline that suggested a certain attitude and personality.

◀ I refined the form of the body and then switched my attention to the head and drew a suitably threatening kind of face that seemed right for the body type, using similar curves and angles to make it a bit ape-like. In a cohesive design, each section or detail influences the design of the whole and vice versa.

▲ Clothing and rendering a figure affects its character and background story greatly. The stylized armour sets this figure very much among sword and sorcery clichés, but what if he were given floor-length robes, a police uniform, or a toddler's romper suit? If he were hairless, scaly or even see-through, the differences would be dramatic.

> **ARTIST'S ADVICE**
>
> Start your monster drawings in the middle of a fairly large sheet of paper, perhaps A3 size (60 x 42 cm/ 23½ x 16½ in). Leave plenty of space for the character to grow in any direction.

◀ Many of the gods, demons and monsters of mythology are human-animal hybrids. Beings such as centaurs, werewolves, the Minotaur and so on have been depicted countless times, but there is always scope for a new take on these age-old subjects. My illustration of this satyr, or devil, shows him as a cheerful, crafty-looking character, basically goat-like below the waist and human above. Others might blend the two species throughout the entire body. He could be made to look monstrous, menacing, debonair or cuddly. How would you draw him?

INSPIRATIONAL DEVICES

There are times when we all suffer from 'artist's block'. The prospect of designing an entirely new life form straight out of your head is likely to bring about such a block – but as you discovered in the first part of this book, inspiration is easy to come by once you grasp the process.

▲ When I thought about drawing a space alien the first thing that popped into my head was Star Trek, so I jotted down the gothic arch shape of that TV programme's logo. With that decision made, the alien grew very quickly. It helped that I went for a symmetrical front view. Formal profile views are also relatively easy to design around.

▲ I often spend rather too long trying to decide on poses and what to do with the arms, hands and legs. For this design I gave myself a head start by basing the drawing around a pose I came across in a fashion magazine. The pose suggested the form and the character.

◄ The face here is based on a sketch of a gargoyle from an ancient building, so that was the starting point from which I imagined a suitable body to match.

▲ It is often the little human touches given to fantastical creatures that work so well on viewers' imaginations. With that in mind, my starting point here was a big ugly human mouth. Why it ended up taking a fish-like form is a mystery to me, but then that is part of the pleasure of this kind of subject.

► Here I started with an apple shape. As a figure emerged, I thought of a bird puffing out its chest with folded wings and trailing tail. That then developed into a Napoleonic coat, the chest crammed with medals and shiny buttons.

▲ This strange creature came about from my looking at big cats for a scary monster design. I imagined a helpless animal that could replicate a fearsome face to scare away predators. The resulting design is not exactly fearsome, but certainly original.

BLOTS AND DOODLES

It is not uncommon for people to see landscapes in the clouds, faces in rumpled cloth or human figures in gnarled old trees (see pages 196–7). Leonardo da Vinci used to gaze at the crumbling plaster of a studio wall and pick out whole marauding armies doing battle in the play of light. Such inspiration can be easily found, or created, to unlock new doors in your imagination.

232

▲ If you concentrate your gaze on a textured surface it does not usually take long for faces to start peering back at you. For example, here is a photograph of a bush in my garden, taken at twilight when the shadows are deep and the imagination is on full alert.

▲ To me, this frightened teddy bear was immediately visible in the rustling foliage.

▶ Then, as I looked harder, the light changed and the breeze rearranged the features into something more sinister.

▲ Back in my studio, I worked on the face and took the characterization another step further.

◄ In the Rorschach test used by psychologists, patients' interpretations of inkblots are analyzed. To create your own inspirational inkblots, moisten some heavy paper with a broad brush and water and lay it flat. Load a brush with diluted ink and splatter the paper randomly, allowing the ink to spread. You could also tip the paper to help the ink run, or, for a symmetrical blot, fold the paper in half and press down hard.

► Stare into your inkblot and allow it to speak to you. Turn it round, hold it up to the light and squint your eyes until improbable visions like this jump out at you. When you see something interesting, use some layout paper to trace off what you see. Follow the inkblot as closely or as loosely as you like.

▲ Look also at the 'negative space' around and inside the inked areas.

◄ For a more direct approach, work straight onto the surface of the inkblot. Here I used inks, pencils and watercolour to cajole this image out of the blot. Once you start looking there is seemingly no end to the possible visions. I can see many more things in this one, and I have not even turned it round. A crocodile, a gibbon, a fish, a boggle-eyed bug … what can you see?

FANTASY LANDSCAPE

All of the inspirational sources and devices that we have seen for drawing fantasy characters can also be used for creating imaginary worlds. Anything that stimulates the imagination is a valid starting point, even childish scribbling.

234

▲ Having found some paper with an unusual mottled surface in a craft shop, I wanted to take advantage of the texture for an alien landscape. Without any preconceptions, I closed my eyes and randomly scribbled over the paper using the point and the side of a soft pencil.

▲ After studying the scribbles, I selected and defined some of the more interesting lines. These would form the framework of the drawing yet to emerge.

▶ As I developed the guidelines into structures, they gradually took on organic forms, rather like seashells and corals. I added some rudimentary windows to give these forms the scale of buildings and imply the hand of alien intelligence in their creation.

◄ At this stage I wanted to give everything a definite form. I decided on the direction of the light and put some tone into all the areas that would be in shadow to form a three-dimensional space. This required a lot of decisions about how each structure would curve and connect with others.

▼ It took quite a long time to refine the rough shapes into presentable artwork. I picked a small figure out of the scribbles and then erased the remaining unwanted marks. I deepened shadows in the foreground and softened tonal contrasts towards the background to give some aerial perspective.
In developing shapes and surfaces I was aided by the paper, which provided an effective grainy texture.

> **ARTIST'S ADVICE**
>
> **Repeating shapes, details and motifs through the drawing gives the design a cohesive feel, however wacky the results may be.**

LANDSCAPE DESIGN

When you have a fairly clear idea of the kind of landscape features you want to draw, you can orchestrate the space just as you would for any other composition. To help you to make the many decisions involved, employing a compositional device can be invaluable (see pages 164–5). You need not stick to them, but starting with geometric shapes, curves, diagonals and so on will get the ball rolling and ensure that you have a graceful or imposing foundation for the design.

◄ After trying out different curves on scrap paper I arrived at these, which, to my eye, have a pleasing, harmonious feel. They may be nothing more than four simple lines, but with a little contemplation they may suggest no end of drawing possibilities.

▲ Following the curves closely, I devised this science-fiction type of landscape. For a comic-book feel, I used felt-tip drawing pens for the line drawing and a white drawing pen for the highlights. A few strokes of chalk and charcoal brought out some gentle tones against the plain grey paper.

▶ A compositional device can be interpreted in many ways. Here the dominant curve became an old cottage and other curves informed the rolling fields and hills in which it is set. Much of the detail for this drawing came from an old woodblock print, the feel of which I tried to capture in the loose black ink brushwork.

237

◀ Before starting this drawing, I found an atmospheric picture of a mountainous landscape. From that single reference source, I could very quickly transfer the landscape details to fit into the shape of my compositional curves. With the rugged texture and heavy pencil and ink tones, the original curves are no longer immediately visible.

▶ Again the original curves are hard to see in this industrial roofscape, but they provided a convenient starting point. I looked at several old photographs of Victorian industrial towns to inform the chimneys, silos and rooftops that are assembled here. For a grim, dirty feel, I shaded roughly and rapidly with very soft pencil and smudged many parts with a fingertip.

MAKING A STATEMENT

In many art schools, drawing and illustration come under the banner of 'visual communication'. Of course there will always be a place for artwork that exists purely for its aesthetic merits, and illustration is very often supplementary to a story or text. Even so, the illustrator should strive to bring out that extra dimension of communication by using visual signals to carry a message, inspire thought or provoke a response.

238

◄ WHIMSY

The brief here called for an ostentatious Gothic fireplace. As it was for a light-hearted book I included a joke element in the form of an old electric fire, which looks ridiculously small and ineffective in the fireplace and highlights the scale and pomposity of its surroundings.

▲ EXAGGERATION

It can surprisingly easy to confuse the point you wish to make. Exaggeration is a good way to avoid any ambiguity. This old couple with their clothing, poses and expressions are clearly huddling round the candle out of necessity, rather than for any romantic reasons. However, with serious themes, be aware that exaggeration can easily look cartoon-like and unintentionally light-hearted.

▼ PROPS

The magnifying glass serves as an extra point of interest in this portrait of Aldous Huxley. It is fitting because he was plagued by very poor eyesight, and with its inverted image it speaks of the peculiar and insightful view of the world the author expressed in his writing.

▶ CONNOTATION

This simple twist on a ship in a bottle accompanied a magazine article about counterfeit medicines. The combination of pirate ship and medicine bottle immediately suggests drug piracy and the skull motif denotes poisonous contents. Then there are the secondary connotations: smuggling, riches, plunder, threat, overseas trade and so on.

239

◀ ATMOSPHERE

This scene of awkward teenage fumblings behind a holiday chalet is given a magical slant by the shapes of the couple's shadows. We can imagine that the youngsters might feel like romantic characters from stories of old, despite the humdrum surroundings.

▶ SIMPLICITY

As we have seen throughout this book, the simplest way to communicate an idea is usually the best; every extra element you include presents more opportunities to confuse, dilute or even contradict your message. Have the confidence to rely upon the simplicity and potency of the artists' pencil as a tool of invention, imagination and communication and you will not go far wrong.

Remember that this book is only a starting point, a humble introduction to the infinite scope of imaginative art – but I hope that it has helped to fuel your creative spark and that you will feel encouraged to further explore the many magical possibilities that drawing holds for you.

INDEX

A

aerial perspective 54–5

angle measurement 23

anthropomorphism 200–1

arrangement making 138–9

atmosphere 104–5, 239

B

basic drawing process 14–15

blots 232–3

blunt instruments 78–9

breadth of view 136–7

bright light 96–7

brush drawing 60–3

C

caricatures 206–7

character 214–15

charcoal 52–3

close viewpoints 134–5

collated composition 174–7

combined composition
 168–70

complex scenes 114–15

composition 164–81

condensed composition
 171–3

connotation 239

continuous line 76–7

costume 212–13

creative composition 178–9

curves 164

D

decorative illustration 194–5

details 13

diagonals 165

distant viewpoints 134

distilled composition 166–7

doodles 232–3

dramatic drawings 216–17

dramatic light 98–101

drawing language 140–1

E

elegance 90–1

emphasis 182–3

erasers 162–3

exaggeration 238

F

faces 202–7, 214–15

fantasy illustration 224–7,
 234–5

figure drawing 24–6, 208–17,
 224–9

form 13, 30–1, 88–9

framing 70–1, 136, 165, 180–1,
 184–7

front view 128

G

geometry 94–5

golden section 162

H

hatching 50–1

horizon 35

human head 27–9

I

illumination 158–9

ink drawing 144–8

invented figures 210–11

L

landscapes 234–7

light 48–9, 96–7, 98–103,
 158–61

line drawing 44–5, 76–7,
 142–5

looking down 130–1

looking at objects 10–11

looking up 132–3

M

marker pens 64–5

mass 13

materials 12

multiple masses 16–17

N

narrative drawing 122–3,
 216–17

non-human characters
 228–31

O

one-point perspective 34

P

paper 18–19, 66–7

pencil line drawing 142–3

personality 120–1

perspective 32–43, 54–5

profiles 128

proportions 20–2, 202

props 238

R

real life 112–13

rear lighting 102–3

rear views 129

receding angles 32–3

reflections 38

restricted tone 74–5

rough drawing 191

S

scales 80–1

scene development 221–3

scraperboard 160–1

serendipity 160

shade 48–9

shading 50–1

shape 13

shapes in perspective 40–1

sight-sizing 20–2, 135

silhouettes 192

simple form 88–9

simplification 141, 239

sinister illustrations 218–20

sketching 84–7

spatial depth 106–7

stages of illustration 190–1

structure 94–5

stylistic faces 204–5

stylistic figures 208–9

subject matter 126–7

surface of objects 108–12

surrealist drawing 198–9

symmetry 92–3

T

texture 46–7, 146–8, 154–7

three-point perspective 42–3

thumbnails 190

time limits 82–3

tone 48–55, 74–5, 149–51,
 154–5

toned paper 66–7, 152–3

tracing 193

transparent media 56–7

two-point perspective 36–7

V

vanishing point 35

viewpoints 128–37, 203

W

washes 56–9, 150

wear and tear 116–19